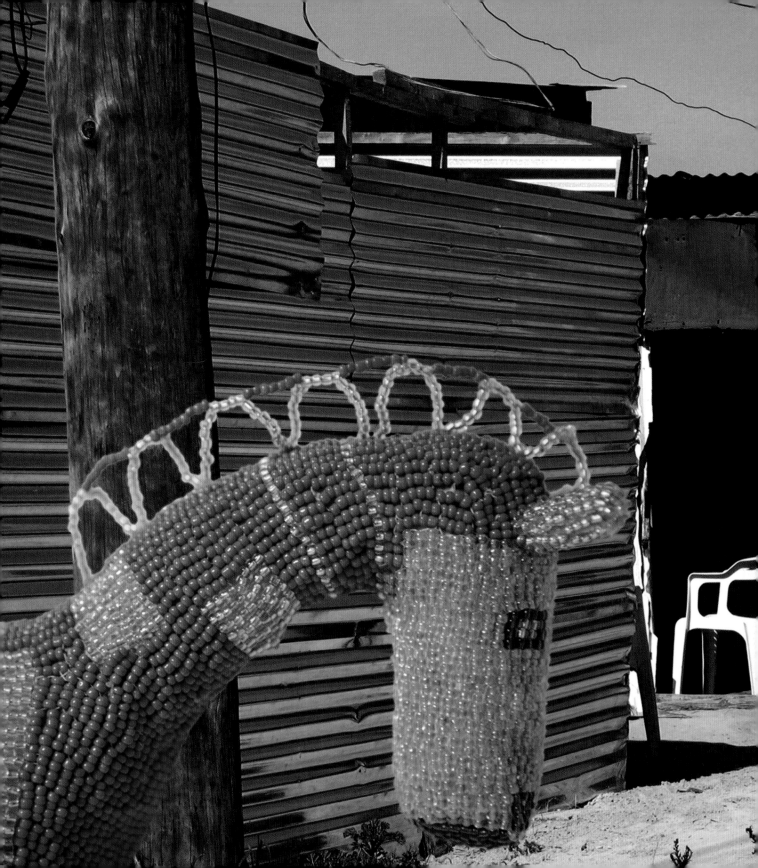

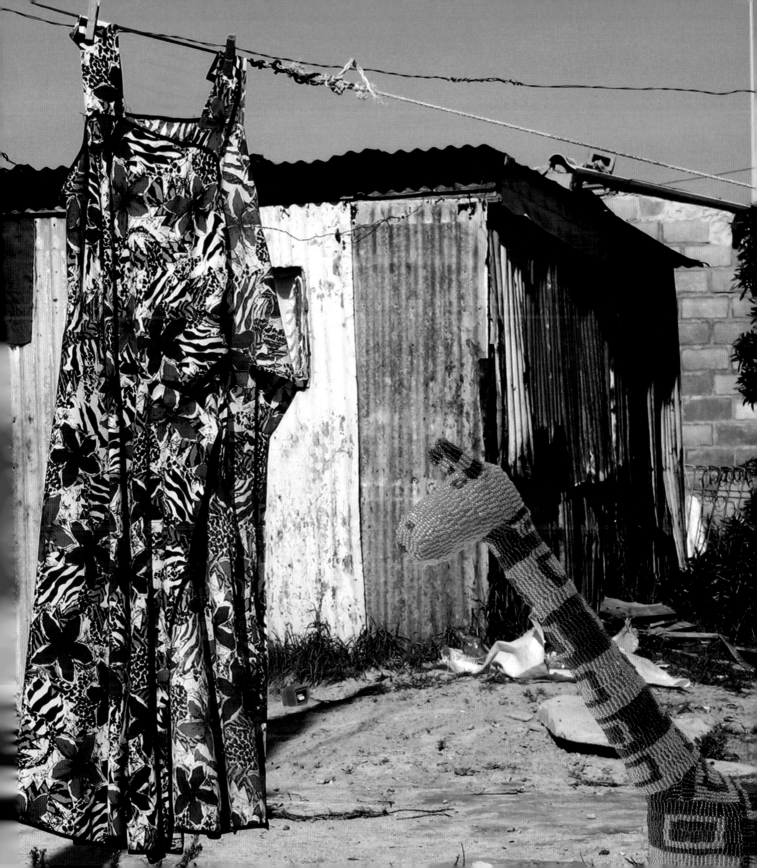

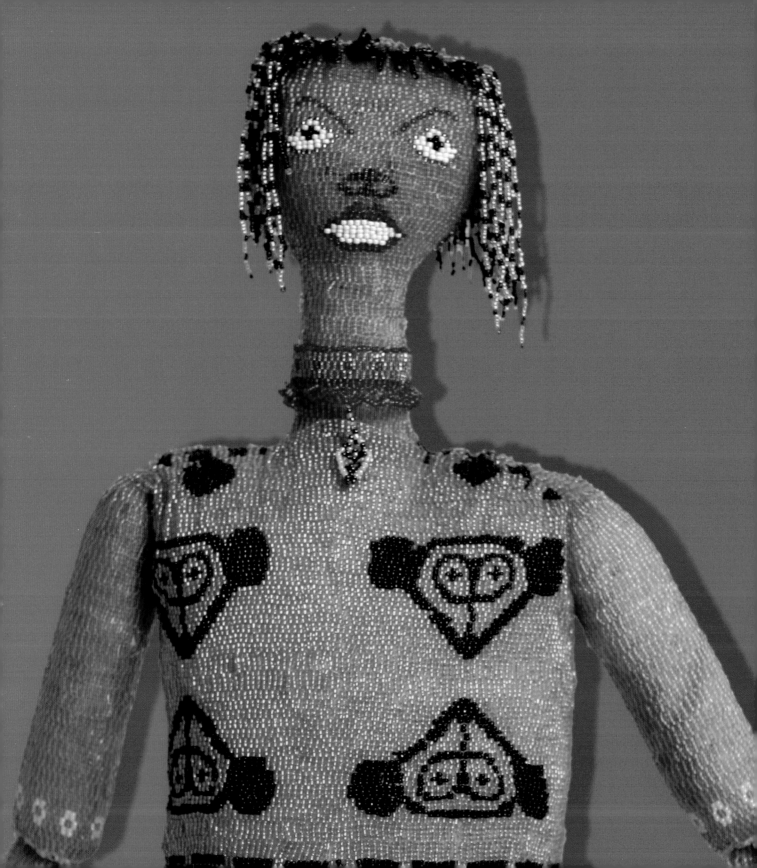

bead
by
bead

Text: Dion Viljoen
Design: Martine Jackson
Photography: David Chancellor, Brett Rubin,
Martine Jackson, Dion Viljoen

Reviving an ancient African tradition

The MONKEYBIZ story

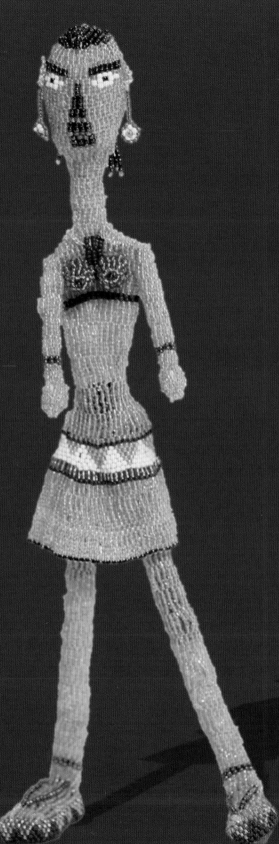

Editing and text: Dion Viljoen

Design: Martine Jackson

Photography: Brett Rubin, David Chancellor, Martine Jackson
and Dion Viljoen; unless where credited otherwise.

Copy editing by Kristy Evans and Shelley Garb

Xhosa translation and editing: Mathapelo Ngaka and
Pamella Maseko

Artist interviews: Joy Conrad, Vanessa Herman and Dion Viljoen

Special thanks to (in no particular order): Russell Martin, Kristy Evans,
Mathapelo Ngaka, Barbara Jackson, Shirley Fintz, Carrol Boyes, Gregor
Klotz, Sarin Stern, Zia Bird, Elizabeth Maarman, Joan Krupp, Michele
Horwitz, Gemma Orkin, Sakhumzi Makaula, Zoleka Valashiya,Namhla
Dabula, JP Gouws, Neville Gray, Makatiso Ngaka, Sikaa Hammer,
Dominique Hazell, Tania Bester, Raffaella delle Donne, Till Manecke,
Ursula Prukl, Miss Gali Ray Ace, Tatum Lataste, Hannah Grabe (aka
Angel Pie Face), Gail Habif, Joanie Shubin, Enid Draluk, Amy Joffe,
Dr Gary Roberts, Kwesi Thomas, Kameko Langston, Amy Sullivan

To contact Monkeybiz or to visit its online store:
www.monkeybiz.co.za

This edition first published by Jacana Media (Pty) Ltd in 2007

10 Orange Street
Sunnyside
Auckland Park
2092
South Africa
(+27 11) 628-3200
www.jacana.co.za

Cover design by Martine Jackson
Cover and back photographs by Brett Rubin and
David Chancellor
Printed by Imago, Job no. ZBED2

See a complete list of Jacana titles at www.jacana.co.za

JACANA

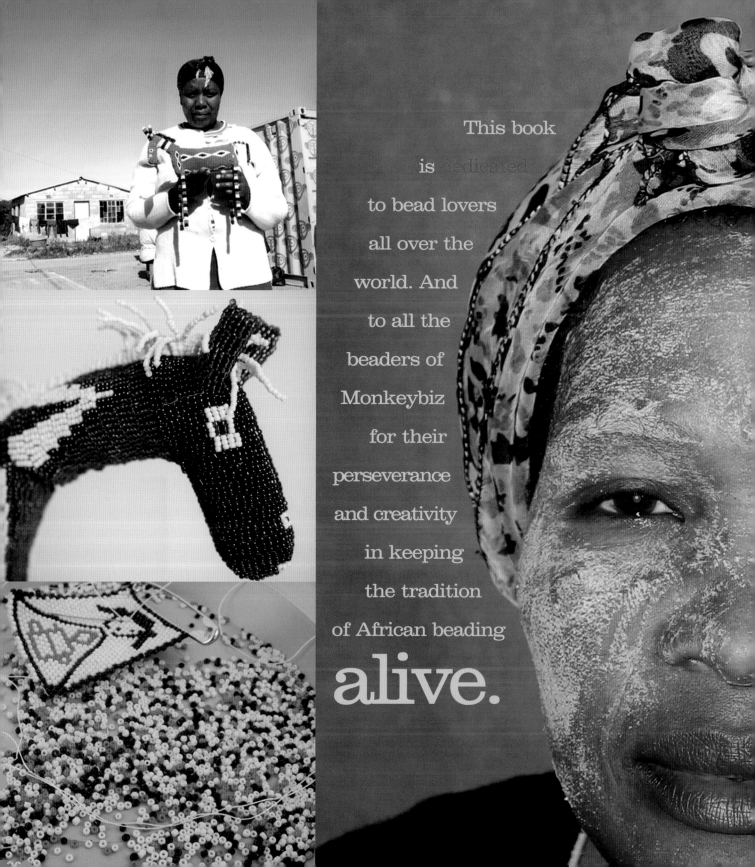

This book is dedicated to bead lovers all over the world. And to all the beaders of Monkeybiz for their perseverance and creativity in keeping the tradition of African beading **alive.**

forewords
& sponsors

Monkeybiz would like to acknowledge and thank the following people and institutions. Without their generous financial support, this publication would not have been possible.

Rutger Hauer Starfish Association
Jacqueline Gahagan
Jewish Federation of Atlanta
Jayne During
Jane Letourneau and John Frey
Andrea and Timothy Collins

Monkeybiz is a pure example of love in action. A diverse group of women came together to channel their passion in a heroic effort to effect change in their community. The women of Monkeybiz use beauty as the tool to create a better world, while constructing a model worthy of profound recognition and propagation.

Paulette Cole
owner, ABC Carpet & Home, New York

Carrol Boyes wholeheartedly supports, and actively assists, the Monkeybiz bead project for the inspirational light they are bringing into the lives of so many women and their families. True charity is not just giving materially, but giving other human beings the means to earn their own income with dignity and pride.

Carrol Boyes
founder, Carrol Boyes Functional Art

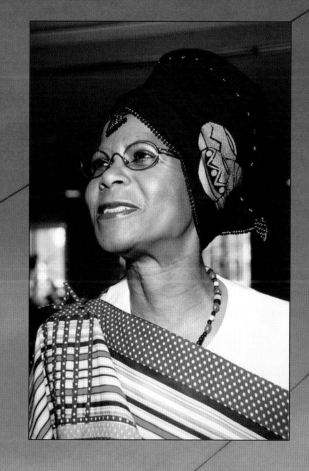

Monkeybiz is a model project that is turning the challenges of HIV into an opportunity to empower women to free themselves from stigma and sexist subordination.

Malibongwe igama la bafazi.

Dr Mamphela Ramphele
Monkeybiz patron and executive
chairperson, Circle Capital Ventures

There's so much product out there in the world, but so little product that makes a difference. And Monkeybiz makes a difference.

Donna Karan
designer

Bead by Bead: Reviving an Ancient African Tradition. The Moneybiz Story is proof that the human spirit can triumph over adversity. Connecting through personal and social transformation, *Bead by Bead*, demonstrates a commitment to create a just, peaceful and sustainable world reflecting the unity of humanity.

Deepak Chopra
president, Alliance for a New Humanity

Bead by Bead is a visual tribute to both the Monkeybiz artists and to the organisers of the project; they have re-ignited a traditional art form with spunk and modernity. This book is a must have for every coffee table.

Dr Frank Lipman
the coolest, kindest Monkeybiz supporter,
the most compassionate physician and
author from New York

Monkeybiz bead project, with its naturally evolving structure, is able to change and transform itself to serve humanity on so many different levels. Its model can be used to revive, preserve, serve and heal cultures worldwide.

Kim Jackson
PR and fundraiser, United States

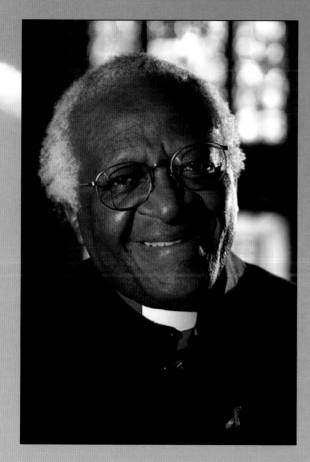

The colourful Monkeybiz beaded artworks are a source of joy and inspiration. They bring beauty and playfulness into our lives and represent the innate creativity of Africa and its people. For those unfamiliar with the magic of Monkeybiz, may this book bring you one step closer.

Desmond Tutu
Archbishop Emeritus of the
Anglican Church in Southern Africa

Monkeybiz is on the front line of the crisis facing South Africa today. Its model successfully tackles cultural continuity, women's economic empowerment and aggressive HIV response in an organic, grassroots approach. Monkeybiz makes each of its stakeholders a social entrepreneur to bring real change to their community and their lives.

Jacob Lief
founder and president, Ubuntu Education Fund

The magical artworks from the Monkeybiz artisans create a bridge between cultures and peoples. They reach out and help heal our souls by giving to both the creator and the buyer through their beauty; for this they are indeed 'priceless'.
I am profoundly honoured to work with Monkeybiz.

Michael Gutte
owner, Enlightened Elephant, Australia

LATHAM & WATKINS LLP

Bead by bead, we transform the world into the place we imagine it can be. Monkeybiz serves as a testament to the power of love in building a new South Africa. Keep the miracles coming!

**Tom Harding and
Dorothy Yumi Garcia**
founders, Art Aids Art, California

Latham & Watkins LLP (www.lw.com) is proud to provide pro bono legal services to support the work of the Monkeybiz bead project.

With each bead, Monkeybiz transforms the lives of its artists, brings beauty to our days, and changes the world.

Kevin Winge
founder, Open Arms of Minnesota

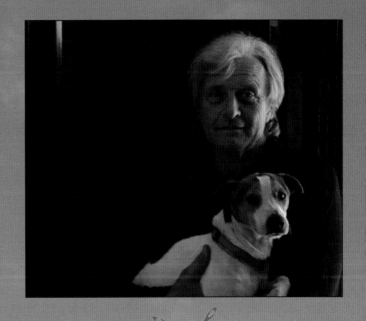

Monkeybiz is women helping women. Real hands helping mothers, daughters, children. Monkeybiz is love for African beads and art. Each piece of Monkeybiz is a piece of heart. Monkeybiz is food on the table and food for thought. Monkeybiz is positively HIV. Monkeybiz is smart. The Rutger Hauer Starfish Association embraces its work.

Rutger Hauer
international actor
and Monkeybiz benefactor

Rutger Hauer Starfish Association
www.rutgerhauer.org

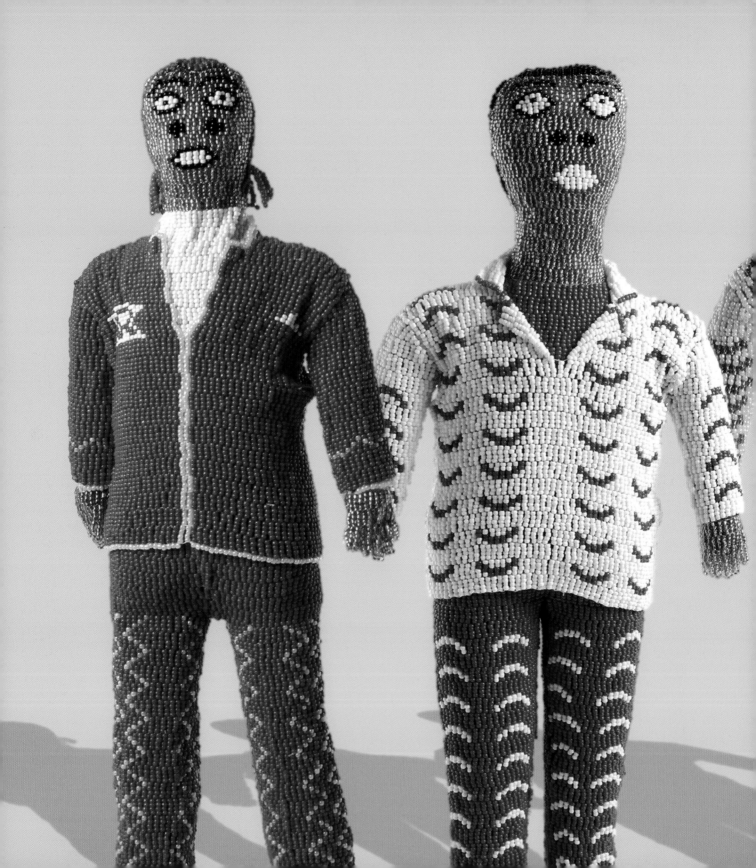

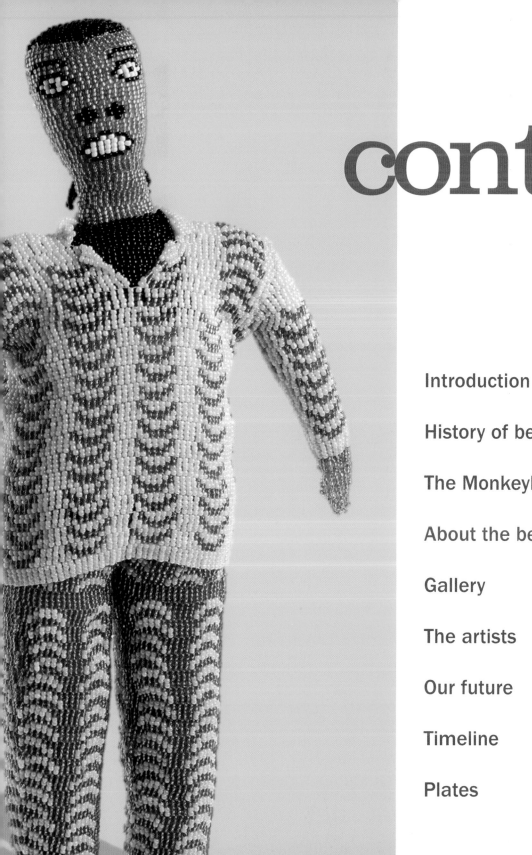

contents

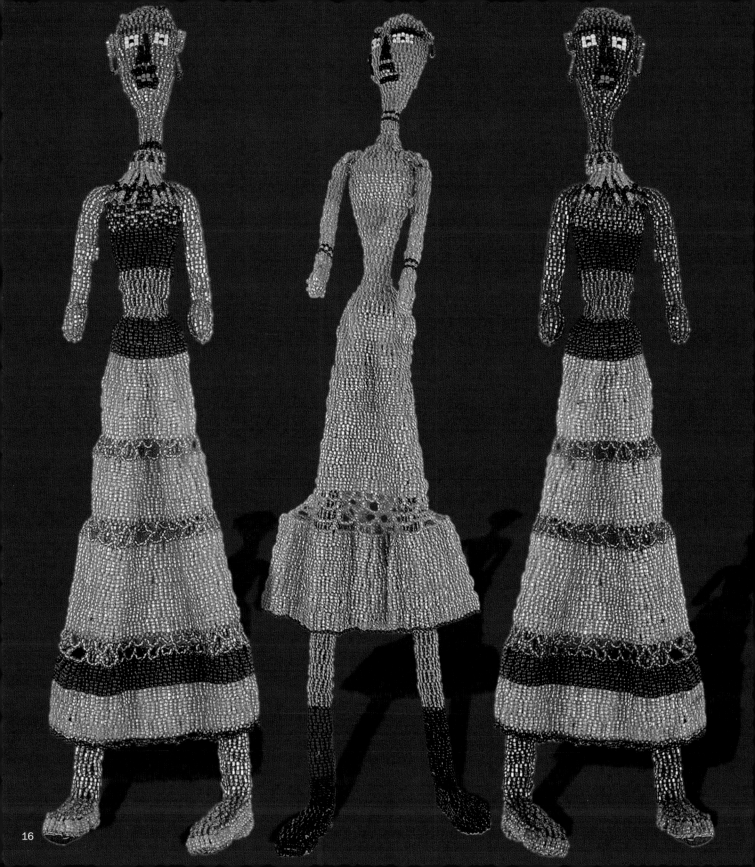

introduction

If life in the townships of Cape Town is extremely challenging in a material sense, each Monkeybiz artwork is a reminder that the human spirit can triumph over seemingly hopeless conditions. Which is why *Bead by Bead* does more than document the Monkeybiz phenomenon – it joyfully celebrates the way in which African creativity manifests itself, akin to an exotic flower blooming in the most improbable of places.

A prominent design feature of this book is the inclusion of seemingly ordinary images from the townships – such as interior wallpaper and lace curtains or the exterior patterns of corrugated-iron dwellings. These provide context for the gallery of the finest Monkeybiz artworks as well as the personal profiles of some of the leading Monkeybiz artists. Their unique creations do not aspire to 'high art' nor lend themselves to intellectual responses, but simply reflect the life experience and reality of each artist.

Among its many remarkable exploits, the crowning achievement of Monkeybiz is that it recognises and develops the artistic ability of people who have never had the opportunity to express themselves through art.

Monkeybiz is the bridge, as it were, between the ancient African beading tradition and the contemporary art market. Since its inception in 2000, the project has won local and international acclaim. That its pieces are sought after by galleries and acquired for both museums and personal collections is testimony to the pioneering role Monkeybiz has played in elevating South African craft art to heady heights.

Monkeybiz is proud of its stable of artists and, with this book, showcases their talent and ability not through words so much as visuals. As you study each piece they have created, you'll recognise its artistic integrity and a typically African vitality and exuberance. You'll also recognise a quality that can only be described as emblematic of Monkeybiz.

The crowning achievement of Monkeybiz is that it recognises and develops the artistic ability of people who have never had the opportunity to express themselves through art.

the history
of beaded artwork

Each Monkeybiz creation is a vibrant statement of contemporary craft art. While it reflects some of the qualities of Pop Art – a riot of bright colours and a superficial playfulness, for instance – it does, in fact, draw on an esteemed tradition of beading on the African continent. From a historical point of view, this is an inestimably long journey. Rigorous scientific methods such as carbon dating continue to reveal a fascinating story.

Until recently, the oldest bead found in Africa was dated to roughly 10,000 BC. Excavated in the Kalahari Desert on the northern border of South Africa, it was chipped from the thick shell of an ostrich egg. Then, in 2004, archaeologist Chris Henshilwood found marine shells and ostrich egg shells at Blombos Cave (a Late Stone Age site on the south coast near Cape Town) that are at least 20,000 years old and had in all probability been used as beads on a necklace.

Through the ages, beads were used not only to adorn the body, but as a measure of value in ritual and economic exchanges. The following example is both non-African and also refers to an exchange between locals and foreigners, whereas the majority of exchanges were within indigenous societies. Arguably the most notorious trade deal in history (fabricated, according to some historians) is taught to school children in the United States: how Dutch traders bought Manhattan – the world's most prized slice of real estate – from Native Americans for a paltry $24 in beads and related trinkets.

In traditional African ritual, a fine bead necklace or beadwork piece is treasured because it is thought to

Colours are invested with meaning. For instance, pink denotes poverty and the use of pink beads could mean: 'You are wasting your money and have no cows to pay for my *lobola* (bride price, traditionally settled with heads of cattle).

I don't love you!"

impart spiritual energy. Although Christianity is the predominant South African religion, it coexists with animism, which pervades life in rural and urban communities through the practice of ancestor worship and the influence of diviners known as sangomas. Beading is central to the sangoma's training. For instance, when a person receives a 'calling', he or she 'takes up the

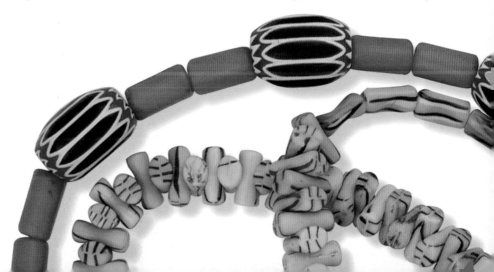

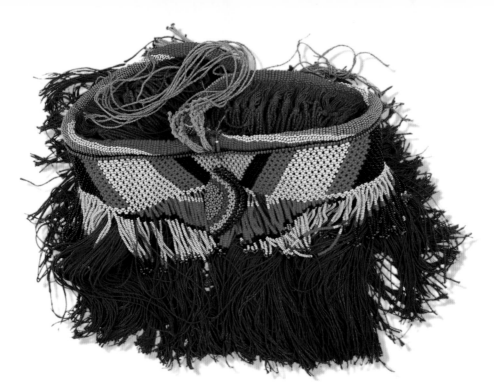

beads'. Thereafter the student makes a series of beadwork pieces to reflect the various phases of initiation and rites of passage.

Precious stone beads and glass beads came to Africa (and southern Africa) from a variety of sources. Chinese and Indian merchants are known to have traded up and down the east coast long before European seafaring expeditions rounded the Cape of Good Hope.

It is, ironically, the city-based project of Monkeybiz that is leading the revival of this venerable tradition by bringing to it a fresh, modern aesthetic.

And Phoenician and Arab traders used to supply beads in exchange for commodities (such as ivory, gold and slaves) that were much in demand during the period of the Egyptian Pharaohs as well as the Roman Empire.

Because of their relative scarcity in ancient times, beads were mostly the possessions of rulers and influential people. A dramatic shift occurred from the late 15th century onwards as a result of contact with Europe. First the Portuguese and later the Dutch, English, French, Belgian and German colonial powers brought millions of Venetian, Dutch and Bohemian glass beads to Africa, making them a common commodity and forever altering the continent's artistic and cultural landscape.

From 1820 onwards, British trade on the Cape eastern frontier, a region known as the Ciskei and Transkei, placed glass beads in the hands of ordinary Xhosa folk. This trend would spread further along the eastern coast among the Zulu and into the interior among the Ndebele, a chiefdom closely related to them.

Ndebele women are arguably best known for the heavy brass rings they wear around their necks and legs, symbol of their married status. But they are also

the time for

renewal **has**

arrived

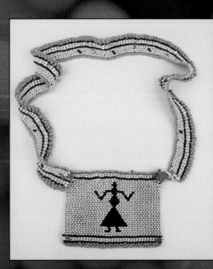

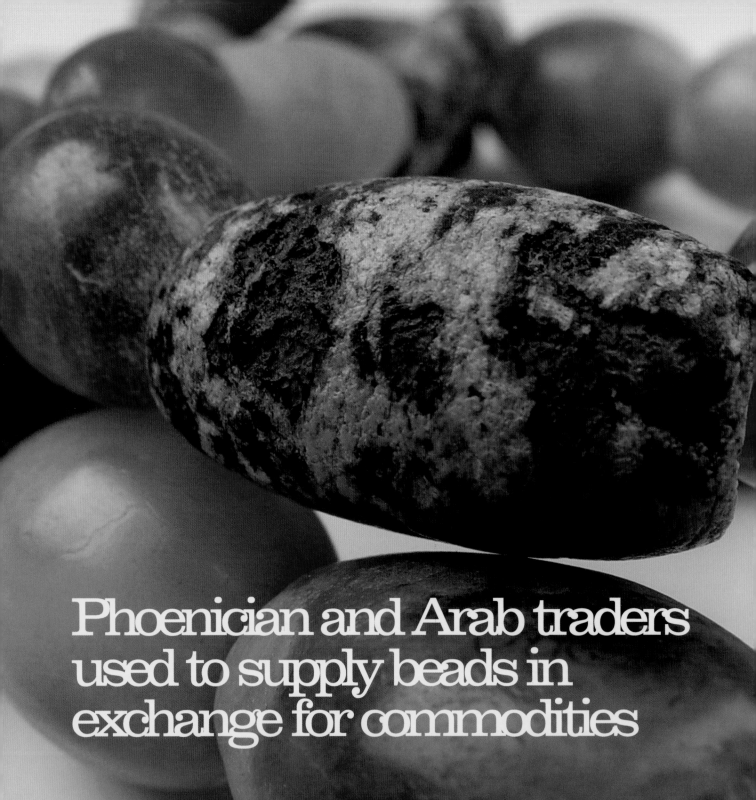

Phoenician and Arab traders used to supply beads in exchange for commodities

renowned for their bead embroidery on aprons, head-dresses and cloaks – and in a variety of intricate patterns echoing the traditional geometric designs on the walls of their houses.

Zulu traditional beading reached its high point during the reign of King Shaka (and also influenced Swazi, Sotho and Tsonga beading through the reach of his mighty empire). So great a bead-lover was Shaka that he decreed any new bead arriving in the kingdom be shown to him. The most unusual ones were kept for himself. When Shaka's mother died, it is said, the wearing of beads in public was banned for a year as a sign of mourning.

Beads became integral to Zulu society. In this non-literate culture, beading developed a whole language of symbolism to communicate messages of love, devotion and betrayal. The famous Zulu 'love letters' are tab pendants made by eligible young women and offered as coded tokens to the unmarried men. Colours are invested with meaning. For instance, pink denotes poverty and the use of pink beads could mean: 'You are wasting your money and have no cows to pay for my *lobola* [bride price, traditionally settled with heads of cattle]. I don't love you!' Love letters aside, messages are also encoded on a huge range of artefacts including bags, belts, collars and headdresses.

In Xhosa beadwork white is the predominant colour. Unique pieces include headdresses made from thousands of white beads, some of them supporting dense drapes of single strands of beads. Both men and women smoke long pipes with beaded stems collo-quially known as *inqawe yase*. The elegant beadwork keeps pipe stems cool enough to handle.

Xhosa beading took political centre stage during the struggle against apartheid. In 1962 Nelson Mandela wore beads of royal lineage for his sentencing at the Old Synagogue Court in Johannesburg. A lawyer by profession, Mandela usually dressed for court in business suits. By wearing the beaded emblem of his people, Mandela signalled his defiance of those who sought to suppress African culture and its expression.

Thirty-two years later, when Madiba took office as the first democratically elected president of South Africa, great changes had taken place. Rapid urban-isation and the predominance of Western material culture had eroded the traditional base of beading. Now the time for renewal has arrived. It is, ironically, the city-based project of Monkeybiz that is leading the revival of this venerable tradition by bringing to it a fresh, modern aesthetic.

Sources: 1. Jean Morris and Eleanor Preston-Whyte, *Speaking with Beads: Zulu Arts from Southern Africa* (Thames and Hudson, 1994). 2. Emma Bedford, *Ezakwanto: Beadwork from the Eastern Cape* (South African National Gallery, 1993). 3. Janet Coles and Robert Budwig, *World Beads* (Ryland, Peters & Small, 2005 edition). 4. Caroline Crabtree and Pam Stallebras, *Beadwork: A World Guide* (Thames and Hudson, 2002). 5. Janice Kaplan, *Images of Power and Identity* (National Museum of African Art, 2004). 6. Lois Sher Dubin, *The History of Beads from 30,000 BC to the Present* (SA National Gallery, 1987). 7. Stan Schoeman, *Eloquent Beads / The Semantics of a Zulu Art Form* (Africa Insight, Volume 13, no. 2, 1983). 8. Lidia D. Sciama, *Beads & Bead Makers / Gender, Material Culture and Meaning* (1998). 9. Ettagale Blauer and Alan Donovan, *African Elegance* (Rizzoli, 1999). 10. Carol Beckwith and Angela Fisher, *African Ceremonies* (Harry N. Abrams, 1999). 11. Carol Beckwith and Angela Fisher, *Faces of Africa* (National Geographic, 2004). 12. Angela Fisher, *Africa Adorned* (Harry N. Abrams, 1984).

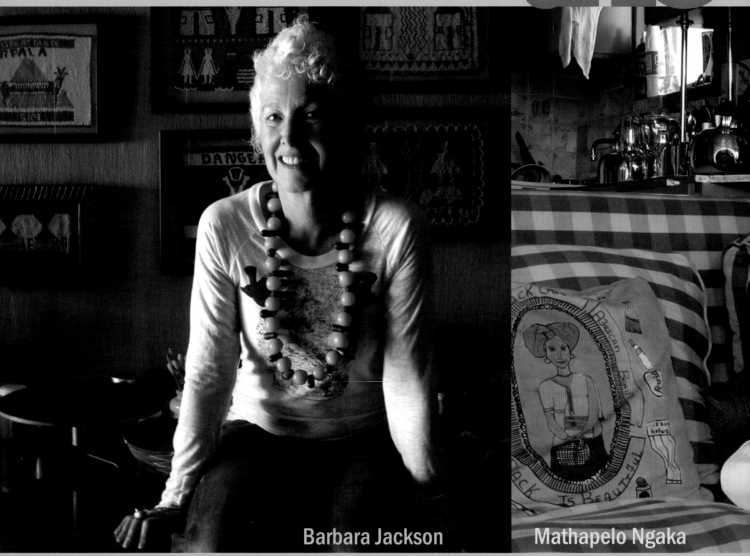

Barbara Jackson

Mathapelo Ngaka

monkeybiz story

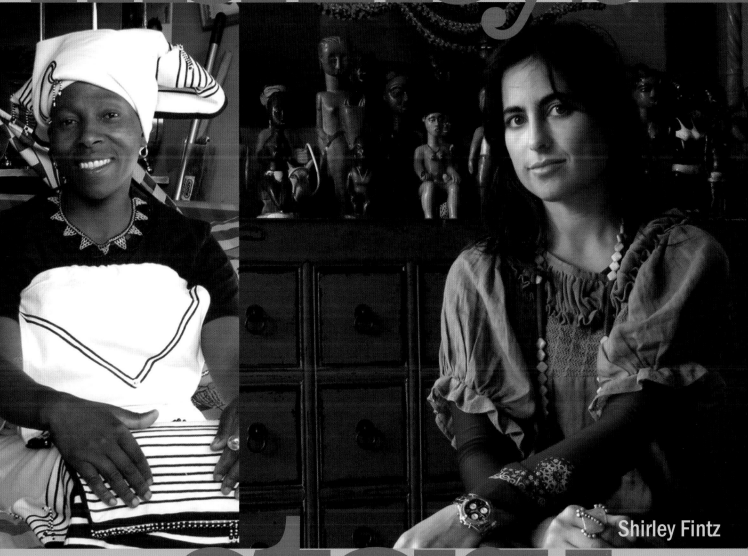

Shirley Fintz

>>

how we started

It started simply – with a beaded doll that made a bold statement. Monkeybiz was never destined to churn out soulless, mass-produced curios for tourists, which are a tired spin-off of colonialism. Instead the acclaimed craft art collective produces something fresh, inspiring and captivating.

That Monkeybiz has transcended the level of trinkets and baubles is largely due to the vision of Barbara Jackson and Shirley Fintz. Friends and established ceramics artists (both are renowned for their audacious approach to clay), Barbara and Shirley are also avid collectors of African art, artefacts, craft art, jewellery and toys with a subversive bent. You could say they share a sixth sense for what is hot and happening in the art world, and what is not.

So, back in 1999, when Shirley, whose speciality is product development, excitedly brought a doll made by her domestic worker to the Barbara Jackson ceramics studio, the proverbial light-bulb moment occurred. Mathapelo Ngaka, a part-time student in the ceramics studio, took the doll and showed it to her mother, Makatiso, an experienced and skilful bead artist. In those days the shops were full of knickknacks that had a certain appeal as tourist souvenirs, yet lacked artistic integrity. Makatiso's brief was straightforward: "Do a doll that looks unique." Happily, the result was so authentic and extraordinary that Monkeybiz was born.

Reflecting on the project's haphazard start in 2000, Barbara has a twinkle in her eye. "No one would take us seriously. We were artists with no business experience and, frankly, we were entering uncharted territory. People could be excused for having thought we were monkeying around." Hence the name Monkeybiz, which satisfied their own sense of irony as much as it poked fun at the establishment.

The early days were difficult. Carrol Boyes, an iconic South

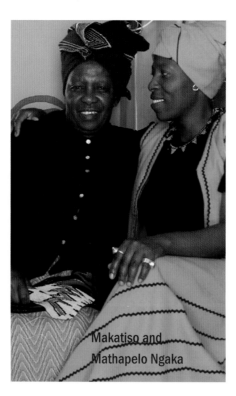

Makatiso and Mathapelo Ngaka

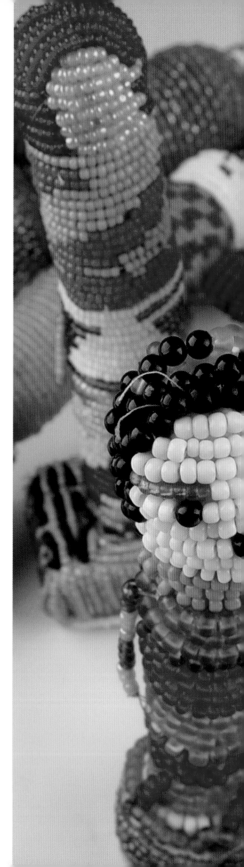

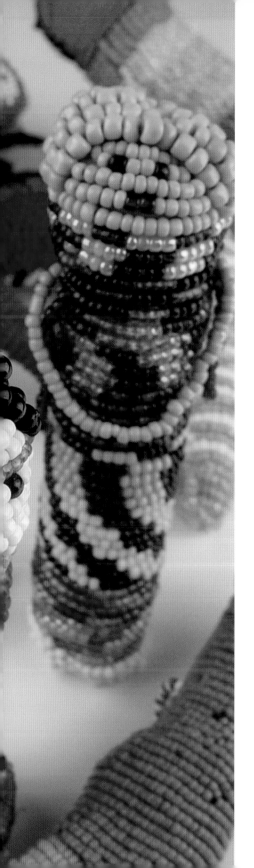

"Helping one another grow strong is what Monkeybiz **is all about**"

African designer, donated office space to Monkeybiz at her headquarters in the Bo-Kaap, Cape Town, and founding directors Barbara, Shirley and Mathapelo sweated blood lugging beads around and motivating the artists. The artists would bring their work to the Monkeybiz office every Friday where all beadwork was purchased on the spot – to a clamour of approval! In those days, the Monkeybiz directors didn't have the

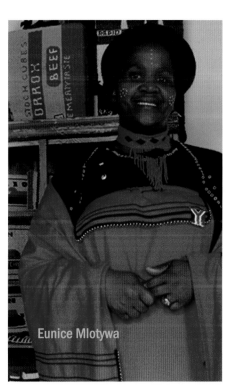

Eunice Mlotywa

heart to turn people away. Nowadays, pieces are accepted only after thorough assessment. Market days have grown substantially and the boisterous passion expressed at the event continues to be an experience to behold.

Even though the first dolls were simple in design and execution, the potential of the beaders was self-evident. "We were delighted," recalls Shirley. "Initially, though, it was hard work convincing people that the items were great. Basically, what we were doing was bringing a contemporary slant to traditional beading techniques."

So convinced were Shirley and Barbara of the integrity of the items that they invested R350,000 (roughly $50,000) of their own money to fund the project – buying more beads and getting additional beaders on board.

"A lot of women didn't have the appropriate skills," says Barbara. "The chain of passing it from generation to generation had been broken because of people migrating to the cities and losing touch with their roots. So we encouraged the women to teach one another in an informal manner."

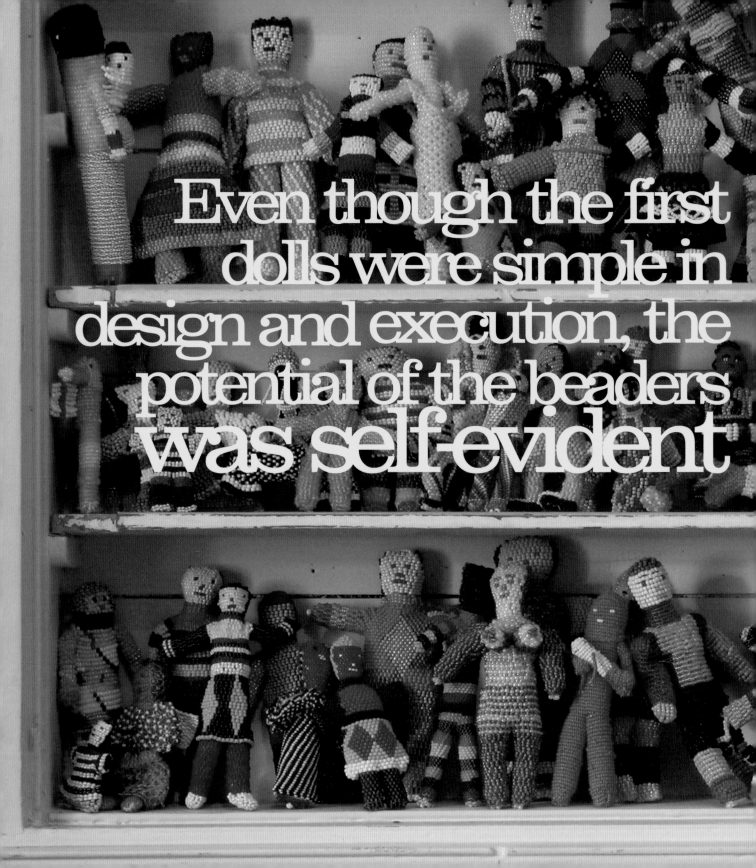

Even though the first dolls were simple in design and execution, the potential of the beaders was self-evident

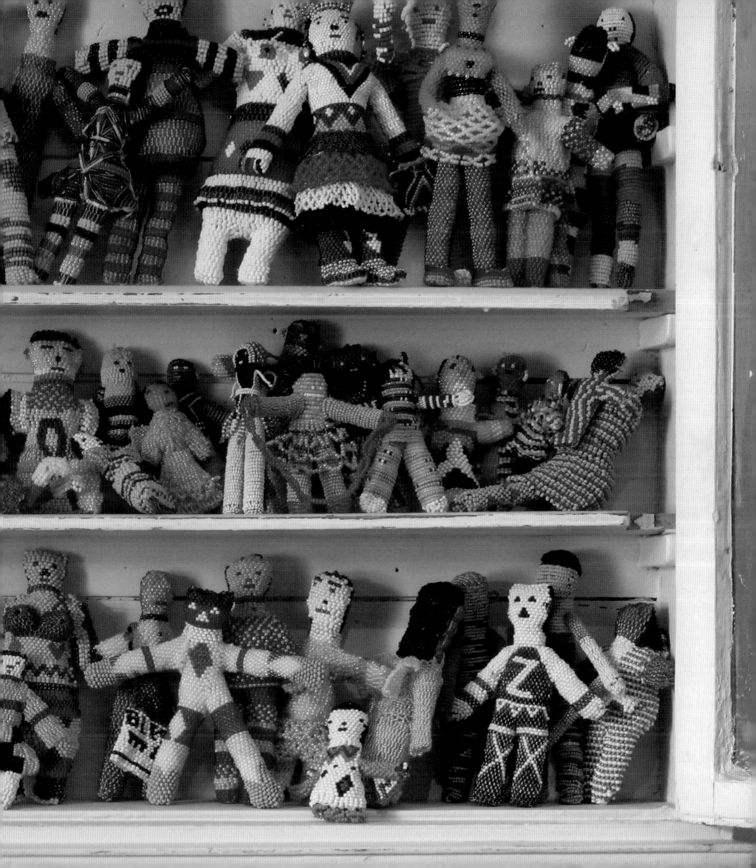

Three people – Mathapelo, Makatiso and Eunice Mlotywa – have played, and continue to play, a critical role in this upliftment process. Mathapelo, the project's community co-ordinator and communications kingpin, is a vital link between the administrative office and the artists in the townships. Makatiso has taught many of the existing Monkeybiz artists how to bead; her house in Macassar, Khayelitsha, is a hive of beading activity.

And Eunice, who along with Barbara had represented Monkeybiz at an exhibition prior to the 46664 concert in Tromsø, Norway, in 2005, is another prominent mentoring figure.

"Helping one another grow strong is what Monkeybiz is all about," concludes Barbara. "It's what we in South Africa call *ubuntu* [helping one another in the common spirit of humanity]."

the story so far

Monkeybiz is unique in many ways. Its primary achievement is that it operates as a non-profit organisation, providing beads and beading material to 450 people, predominantly women, in the informal settlements of Macassar in Khayelitsha, Samora Machel in Philippi, and Imizamo Yethu in Mandela Park, Hout Bay.

It purchases artworks, markets and sells them locally and internationally, and ploughs back the profit through a range of services to the collective. Its employment and skills development profile is exceptional, the latter aspect mirrored by the steady rise in the overall quality of the pieces. From meagre beginnings when dolls were literally constructed of sticks, some artists now confidently create sophisticated animals and a variety of other works of art destined for prestigious museums and galleries.

Yet, despite its phenomenal growth and financial success – against all odds, it has maintained a sustain-able business despite a continual lack of external funding, a benchmark for non-profit organisations – what defines Monkeybiz is that it has retained its creative zest. The dynamic input of the founding trio continues to be matched by the vitality, individuality and talent of the artists. Each item produced by the project is an

"No one likes to be poor. No one likes to depend on handouts, on the charity of others. A project such as Monkeybiz addresses a very deep human need, in that it helps people to help themselves."

authentic, one-off work of craft art. No surprise then that international acclaim has followed.

Also known as folk art for its natural, unaffected expression, Monkeybiz pieces were snatched up at Sotheby's Contemporary Decorative Arts exhibition in

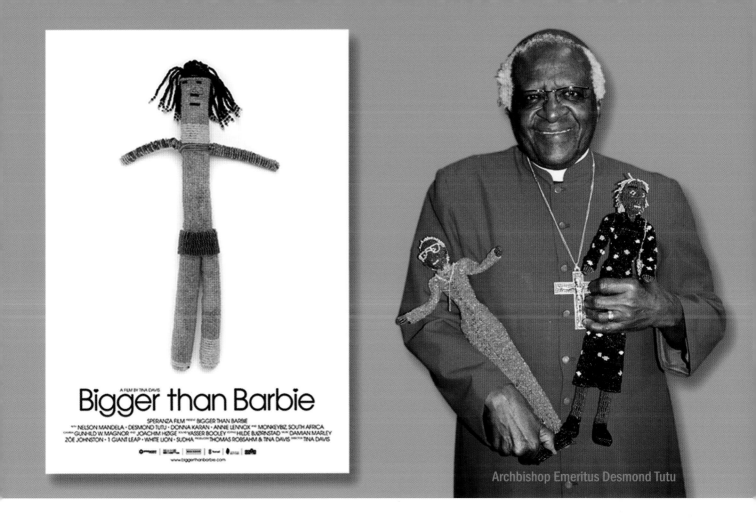

Bigger than Barbie

A FILM BY TINA DAVIS

SPERANZA FILM BIGGER THAN BARBIE
NELSON MANDELA · DESMOND TUTU · DONNA KARAN · ANNIE LENNOX MONKEYBIZ, SOUTH AFRICA
GUNHILD W. MAGNOR · JOACHIM HØGE · YASSER BOOLEY · HILDE BJØRNSTAD · DAMIAN MARLEY
ZOE JOHNSTON · 1 GIANT LEAP · WHITE LION · SUDHA · THOMAS ROSSAHM & TINA DAVIS · TINA DAVIS

www.biggerthanbarbie.com

Archbishop Emeritus Desmond Tutu

London in 2002. The vibrant dolls, animals and beaded 'pictures' have enthralled fastidious shoppers in Conran design stores in New York, London, Paris and Tokyo. Donna Karan, the famous American designer, has been selling Monkeybiz craft art in her eponymous New York store, DKNY, on Madison Avenue. You'll also find these pieces at ABC Carpet & Home, a department store that is a New York institution.

Through the tireless work of Barbara, the project's spokesperson and marketing dynamo who draws on all her connections in international art and design circles, Monkeybiz is periodically involved in exhibitions throughout the world. It has also received foreign publicity through Norwegian and Spanish television documentaries, not to mention a spot on CNN. It was even the subject of a recent short documentary, *Bigger than Barbie* – a tongue-in-cheek title reflecting the ambitious nature of the project.

Bigger than Barbie (which, among others, features pop diva Annie Lennox) was made by the Norwegian director Tina Davis. On her own initiative, she followed Monkeybiz around the world for four years, documenting its rise. Donna Karan makes a cameo appearance in the movie. "There's so much product out there in the world, but so little product that makes a difference," she says. "And Monkeybiz makes a difference."

Desmond Tutu, Archbishop Emeritus of the Anglican Church in Southern Africa, echoes her sentiments: "No one likes to be poor. No one likes to depend on handouts, on the charity of others. A project such as Monkeybiz addresses a very deep human need, in that it helps people to help themselves."

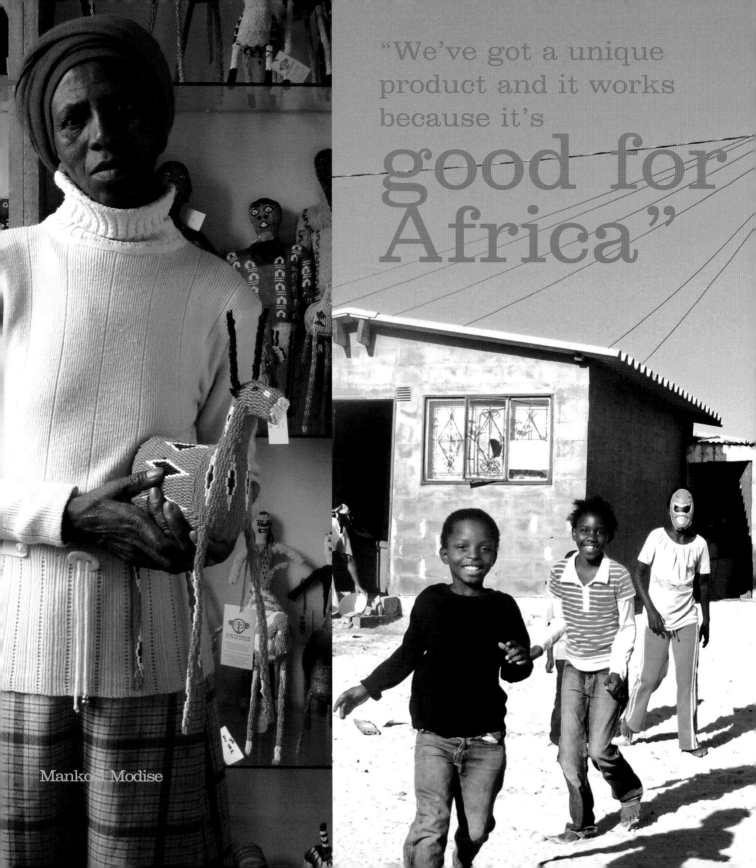

"We've got a unique product and it works because it's

good for Africa"

Mankosi Modise

economic development

The majority of Monkeybiz artists have known poverty, neglect and deprivation for most of their lives. Against this backdrop, Monkeybiz has achieved tremendous impact by providing a basic income to many families who would otherwise have been left destitute.

"The women bead at home and can look after their children while getting on with their other duties," says Mathapelo. "They also have no transport costs because we bring the beads and cotton to them. The beading lifts their spirits; they all share in a sense of achievement. Personally, I too feel happy. I'm from a poor family, but at a material level things are much better now. There's bread on everyone's table."

While Mathapelo has visited New York and other international destinations to help promote Monkeybiz, many women who maintain a much lower profile in the business attest to the principle of upliftment. "Beadwork is very important for me," says Mankosi Modise. "If I didn't know how to do beadwork, I would be eating from the trash cans."

The plight of Mankosi, incidentally, was poignantly aired on *Bigger than Barbie*. She cares for the children of her brother and sister, both of whom had died of Aids. "I hope God gives me strength so that I can raise the children in a proper way. My life has changed since I started working for Monkeybiz. Now I can afford to send the kids to school."

Mankosi and her fellow artists have incentives to strive for. "We pay the women according to the quality of their work," says Barbara. "It encourages them to improve, to aspire to higher standards." As a measure of its commitment, Monkeybiz annually reinvests all its profit in the beading community.

One of the most rewarding aspects of the business, reflects Shirley, "is to help people become artists; those who weren't even aware of their own talent. All our success at overseas exhibitions – some of our artists probably don't even understand what it means. Yet to see a progression in their work is very satisfying."

She also comments on progress in a material sense. "Not so long ago, some of the beaders were the poorest of the poor. I recall a couple wearing black plastic refuse bags when visiting us at the office. Nowadays we see the artists dressing up, buying furniture and television sets. Shack dwellings are being replaced by brick houses. This is as rewarding an aspect as seeing the new sophistication of their work."

For all its diverse achievements, Monkeybiz sets yet another standard, in terms of sustainable development and black economic empowerment (BEE). Where the former is concerned, Monkeybiz uses discarded off-cuts from clothing manufacturers as the filler material for beaded dolls and animals. In addition, it has developed a line of recycled rubber pieces, including jewellery, picture frames and bags.

Legislation passed in South Africa in 2003 encourages firms to adopt BEE strategies to promote diversity in the management and ownership of businesses. Monkeybiz has excelled by achieving the second-highest BEE accreditation rating in South Africa. Small wonder the project continues to receive enormous support from overseas, especially the United States.

Reflecting the stellar growth – its pieces are stocked in stores throughout the world – and burgeoning self-confidence, Monkeybiz has opened a retail store in the Bo-Kaap, a historic neighbourhood adjacent to the Cape Town business precinct.

Apart from providing more permanent employment opportunities, the building accommodates the Monkeybiz Wellness Clinic (profits from the store fund this aspect) and is a visible beacon of the project's success.

"We've got a unique product and it works because it's good for Africa," says Barbara. "The continent is never going to become industrialised on the same scale as China.

"Small businesses provide the means for people to make money and improve their economic situation. There are a lot of talented people who have never had any formal education, but who can produce goods for, say, the homeware, tourist or art markets. Monkeybiz seeks to inspire people to get involved in similar projects in South Africa and throughout the world."

women's empowerment

Not content to be passionate solely about its craft art, Monkeybiz is committed to women's empowerment. Its range of services – a Wellness Clinic dealing predominantly with issues related to HIV/Aids and offering free consultations with volunteer homeopaths and medical doctors, a soup kitchen for basic nutrition, yoga classes, a choir, drama workshops, a crèche and a burial fund – is underpinned by an ethos of social consciousness.

In the context of a collectivist African culture, women have traditionally borne the brunt of the scourges of poverty, crime, violence, minimal education and poor health services. The HIV/Aids pandemic has been inflicting tremendous hardship on women, who often have to care for ailing relatives, even those who are distantly related. Monkeybiz tries to make a difference. The burial fund is a case in point. "People were using all their cash for funerals," says Barbara. "It's been a huge aid to the Monkeybiz community."

Nomzoxolo Jongqo, who recently lost her husband through a heart attack, has become a single mother caring for five children. To have Horatius buried according to traditional ritual in the distant Xhosa heartland of the Transkei would have cost her R9,000 (roughly $1,300).

"Yu! I'm very happy Monkeybiz helped me pay for this." She reflects for a moment, then brightens up. "When I first came to

Cape Town I couldn't have dreamed I would be part of a project like this. I feel very proud."

Canadian-born Kristy Evans, the Monkeybiz organisational development manager who has worked for international women's rights groups, says the project empowers women with a three-pronged approach that intersects at the grassroots level.

"It functions at an economic level, through health and related services, and through art, which is very unique. Monkeybiz gets to the heart of women's empowerment because it's 'on the ground'. The big challenge is to give people the power to have control over their own lives. Putting money into people's hands actually works: you have to enable people to buy bread and feed their children first. Skills training and education come later."

The Monkeybiz empowerment approach is remarkable because it encourages the women to have dignity and pride in their work. It's based on the philosophy of making artists self-sufficient, to understand business and to take responsibility. The women work in their own homes, where they can take care of household duties. "They're not doing a mindless job on some obscure factory line," adds Kristy. "They're creating their own thing, expressing their individuality. It's extraordinary because it really values women's work, which often goes unpaid and unnoticed."

Monkeybiz's women's empowerment approach is endorsed by the presence of Dr Mamphela Ramphele as its patron. A key role-player in the Black Consciousness Movement during the struggle against apartheid, she is the first woman and the first black South African to have held the position of vice-chancellor of the University of Cape Town.

Formerly one of four managing directors of the World Bank, Dr Ramphele is the executive chairperson of Circle Capital Ventures and a leading business executive. "Monkeybiz shows leadership in making South Africa a better place for those at the bottom of the social ladder," she says.

hiv/aids

A large percentage of Monkeybiz artists are either HIV-positive or care for people who are dying of Aids. The immense impact of the pandemic on the beading community has spurred Monkeybiz to action. In 2003, a generous grant from the Norwegian Agency for Development (Norad) provided the essential funding for the establishment of the Wellness Clinic.

This thriving centre, located in the same building as the Monkeybiz store, caters for 60 women once a week. They receive beadwork training, HIV/Aids counselling, yoga therapy, homeopathic and medical HIV/Aids treatment, basic nutritional education, drinks and a warm, nutritious meal.

Monkeybiz also provides women with money for taxi fare to and from the clinic on a weekly basis, as well as a bag of nutritious porridge to take home. Subject to additional financial support, Monkeybiz is trying to expand the clinic so it may serve a growing number of women who are HIV-positive.

HIV/Aids was also addressed in 2003 through a beadwork-illustrated book in English and Xhosa called *Positively HIV*. Funded by Norad and produced in association with Isandi, a Norwegian arts and crafts distribution company, Monkeybiz published a book filled with striking beadwork, graphics and text aimed at educating South African youth.

Positively HIV was named as one of the Top 18 Books for the New Democracy by Exclusive Books, a national bookselling chain. The collector's edition includes a five-track music CD, entitled *Statements*, which features the vernacular narratives of Monkeybiz bead artists mixed into electronic dance tracks by the Norwegian SaS group.

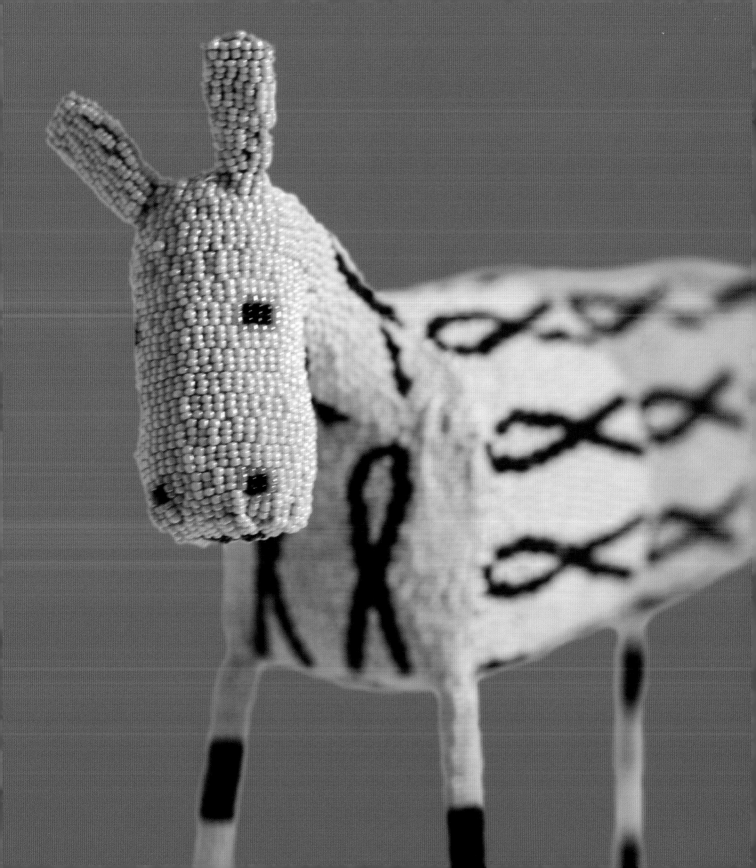

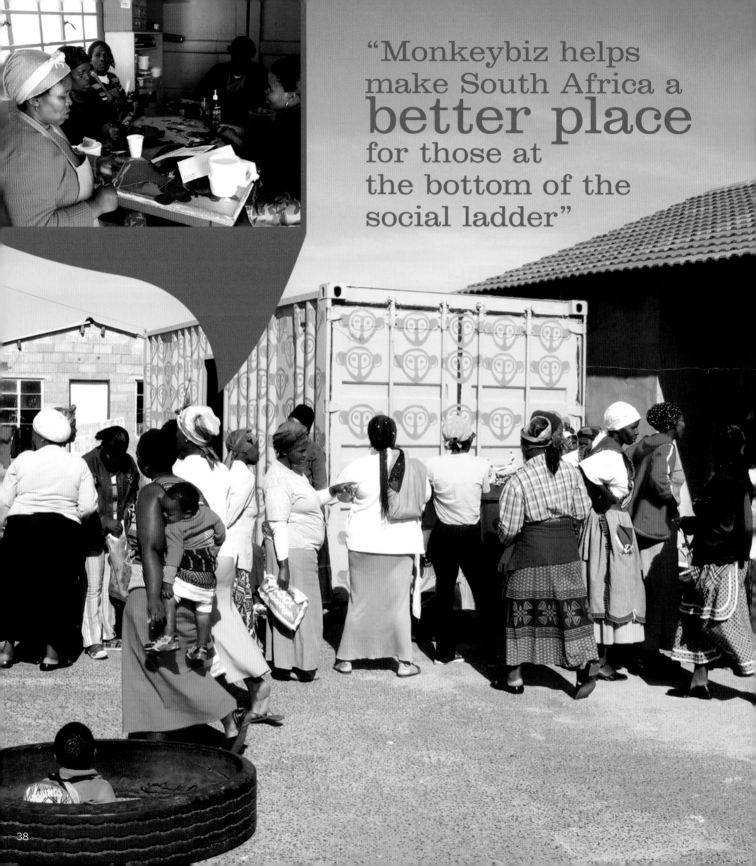

"Monkeybiz helps make South Africa a **better place** for those at the bottom of the social ladder"

Monkeybiz provides a range of services to its community of bead artists. By doing this, it ensures the artists have access to the support they need to maintain their health and well-being. As a non-profit organisation, all sales from bead art go directly and indirectly (through services and the day-to-day running of the project) to the community.

At the Wellness Clinic, a group of volunteer doctors, homeopaths, nutritional and other healthcare experts contribute their time and knowledge. Others who volunteer their services on a regular basis are playwright Myer Taub (drama workshop), music diva Aviva Pelham (choir), two nursery school teachers (Agnes Noqabule and Lindelwa Siphethu) who run a crèche while mothers are doing workshops, and various yoga teachers.

Since 2004, Monkeybiz has created recycled rubber products. In a workshop in Macassar, Khayelitsha, artists make rubber jewellery, dolls and bags from recycled tyres. The workshop is located in a shipping container donated by the California-based Art Aids Art (founded by Tom Harding and Dorothy Yumi Garcia) and a group of African American women who called it The Boat, because it reminds them where they came from in the context of slavery.

Here Sikaa Hammer guides five artists in the production of amazing items, including a delightful doll known as Zolo – short for Mafikizolo (meaning new kids on the block). The artists acquire skills in working with metals such as recycled copper and aluminium, used in necklace and bracelet design. They also learn skills in hammering, filing and moulding, which are transferable to other artistic fields.

Monkeybiz recently launched a burial society for its artists. Because of HIV/Aids, the number of expensive funerals occurring in the Monkeybiz community has skyrocketed, resulting in severe financial constraints on the women.

Monkeybiz contributes half of the costs of a funeral plan per month. This covers often costly funeral-related and travel expenses to the Transkei.

Other financial services include interest-free loans and the opening of a personal bank account for each artist. In a country where the large majority of the people don't have access to the formal banking sector, this is no mean feat.

In May 2006, Monkeybiz launched a soup kitchen. Thanks to a year-long donation from Kevin Winge, founder of Open Arms of Minnesota, it has been able to provide hot meals, bread and butter, fruit and hot drinks to the Wellness Clinic once a week, as well as to those who attend the big market day once a month. The continuation and expansion of these services depend to a large extent on financial donations.

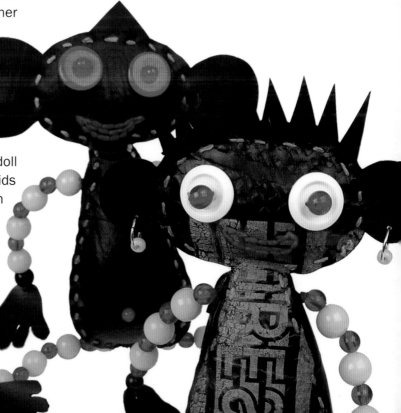

the challenge

Ever the visionaries, the three founding directors are constantly planning ahead. Mathapelo reckons Monkeybiz will soon have to confront the reality of caring for Aids orphans. "Somehow, we're going to have to find ways of taking care of the kids once their parents pass away. More immediately, helping the beaders gain business skills remains a big challenge."

If it manages the process with the same innovation it applies to beadwork, Monkeybiz may well become a South African icon. "Our product is the secret to conquering the market. It's such an honest product," beams Barbara. "Whether it's a small angel or a large animal, it's a beautiful artwork, lovingly made. We've created a market that operates on the principle of 'if you like it, you've got to buy it'. You're not going to get a second chance, because it's an authentic, one-off work of art. Even our price tags tell a story. On the reverse side, artists sign their signature. Some even write down their bank account details!" All of which is why people feel good when they buy a Monkeybiz artwork. "They know that what they're paying is going towards helping people, not just into a bottomless pit."

Shirley, too, is upbeat about the future. "I think the biggest blessing is that we've grown organically over the years. Yes, we've made mistakes, but ultimately we've managed to keep the business on a sound footing. So I feel the biggest challenge is to just keep on doing what we do best. The rest will take care of itself."

"There's so much product out there in the world, but so little product that makes a difference. **Monkeybiz makes a difference.**"

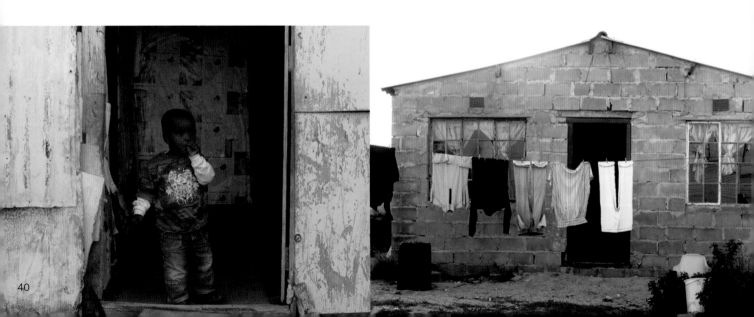

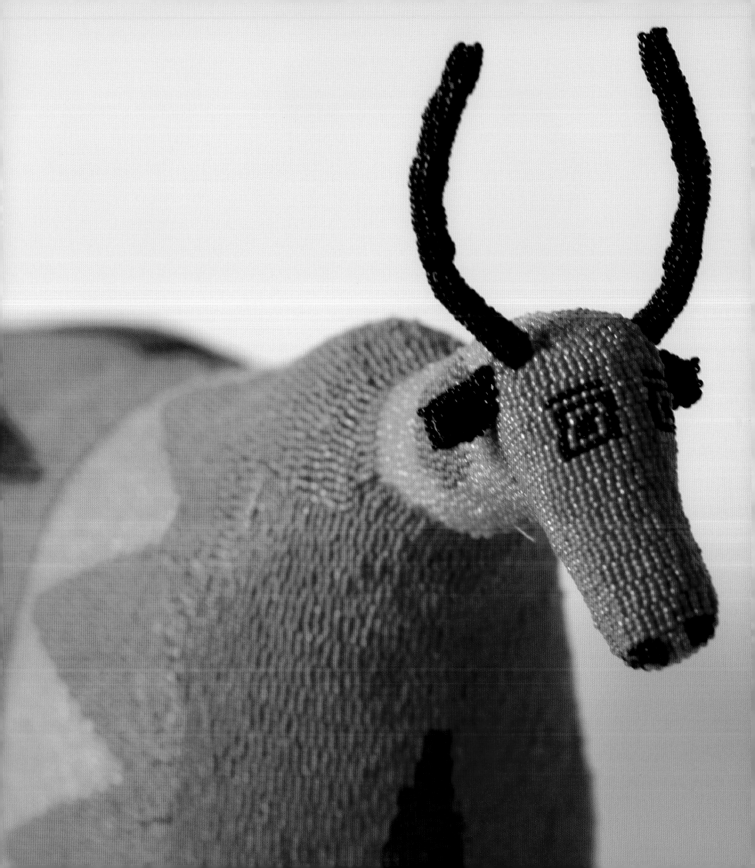

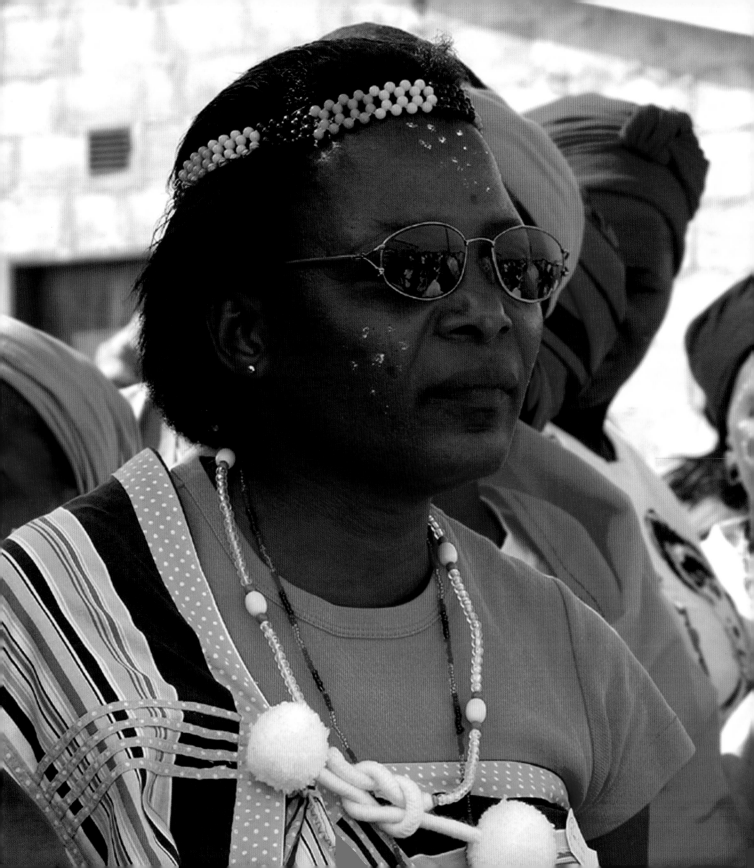

about the

Monkeybiz artworks are suffused with the vivid colours, textures, stories and expressions from the townships of Cape Town. Here, African culture is at its uninhibited best. What may seem disorderly to people from industrialised societies is, in fact, a warm celebration of life.

In Macassar, Khayelitsha, where almost an entire neighbourhood of bead artists is flourishing in the vicinity of Makatiso Ngaka's house, pulsating kwaito music – a typically African, bass-heavy genre that was invented in 1994 to celebrate the birth of a democratic South Africa – spills from an establishment called Jam Alley. Colloquially known as a shebeen (or local pub), it's where members of the community shoot pool, have drinks and groove to the latest dance tunes.

Chickens, cats, dogs and other animals such as cows come and go at their leisure, seemingly oblivious to the demarcation of private and public space. Hordes of children play everywhere – it is not uncommon for toddlers to hang out with families other than their own – and staple Xhosa dishes such as *umnqusho* (samp and beans) are often shared communally.

This is the creative backdrop of Monkeybiz. Within the beading community, teamwork is the modus operandi, though individuality is also valued. Each artist chooses her (or his) own combination of colours, intricate zigzag designs or geometric shapes. Bead by bead, each artwork takes shape organically, much like the rest of life in the townships.

The inner structure of each artwork is constructed of wire, to which recycled cotton clothing off-cuts are added as stuffing. Monkeybiz purchases all its beads in bulk. Seed beads are used to ensure the best quality and, of course, to lend maximum lustre.

The artworks are not just pleasing to look at – you'll want to handle them, to feel their tactile surfaces. But where to start? The range of artworks is phenomenal: from tiny angels to large beaded dolls; from two-dimensional beaded 'pictures' to enormous three-dimensional animals such as giraffes and elephants; from delicate jewellery to gigantic beaded replicas of consumer products such as Lion Matches, Marmite and Heinz ketchup. The Monkeybiz diversity finds expression in a huge variety of shapes and sizes.

Happily, all Monkeybiz pieces have one thing in common: each one is worth collecting. This is because no two Monkeybiz artworks are the same and, to honour the one-off creation of the artist, the flip side of each price label carries a signature. It serves as a guarantee of uniqueness and is a direct, authentic link between you and the African artist. Turn the page, enter our gallery and feast your eyes.

beaded artworks

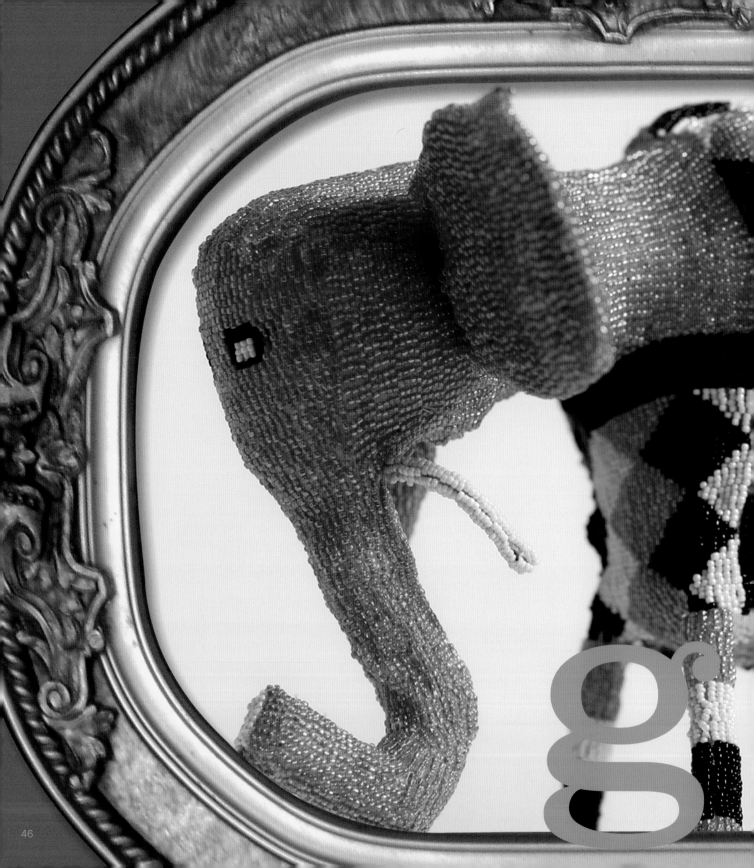

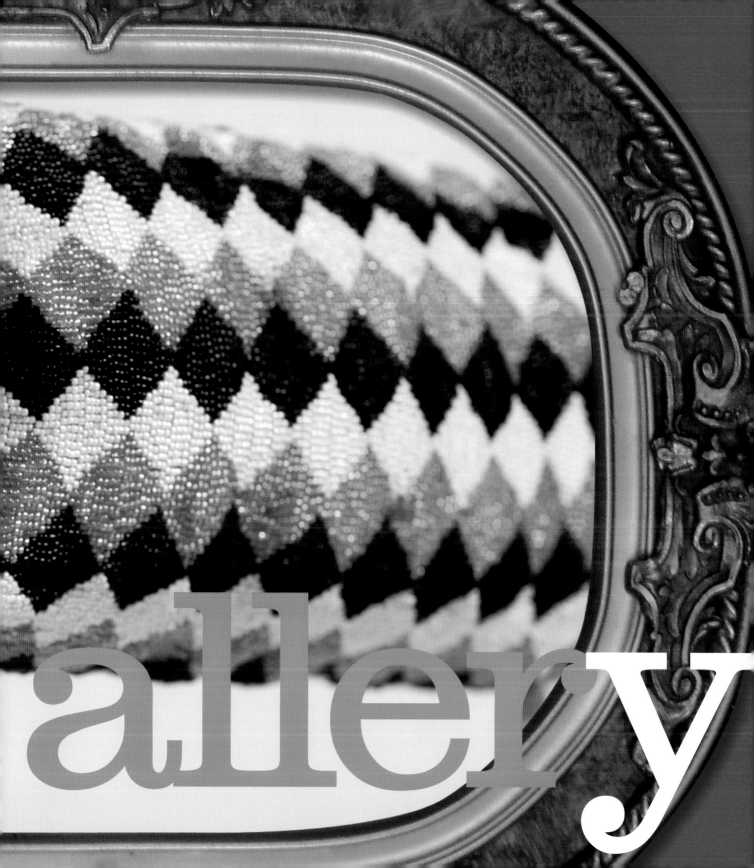

allery

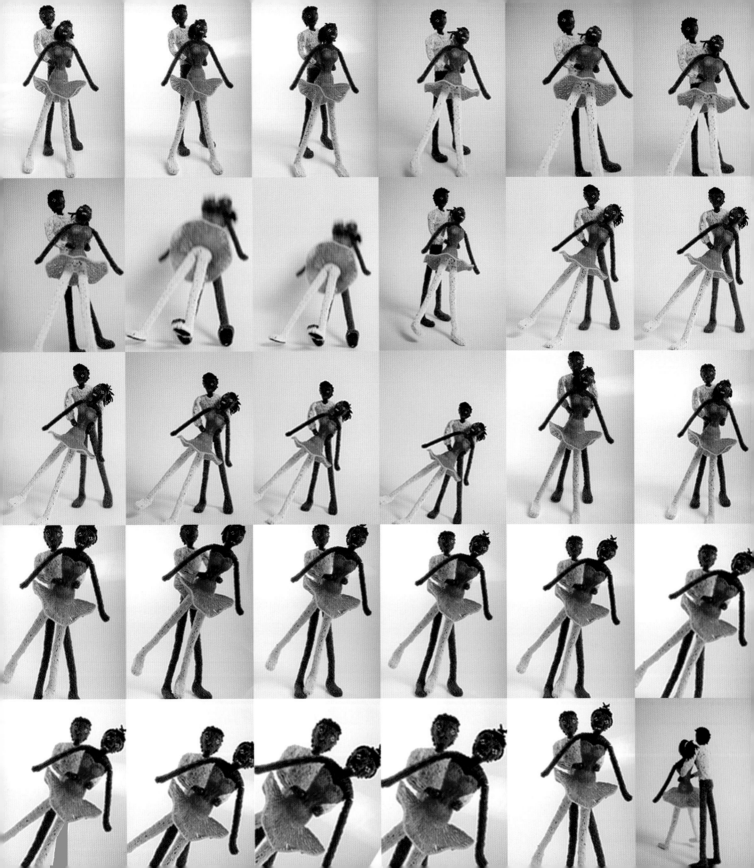

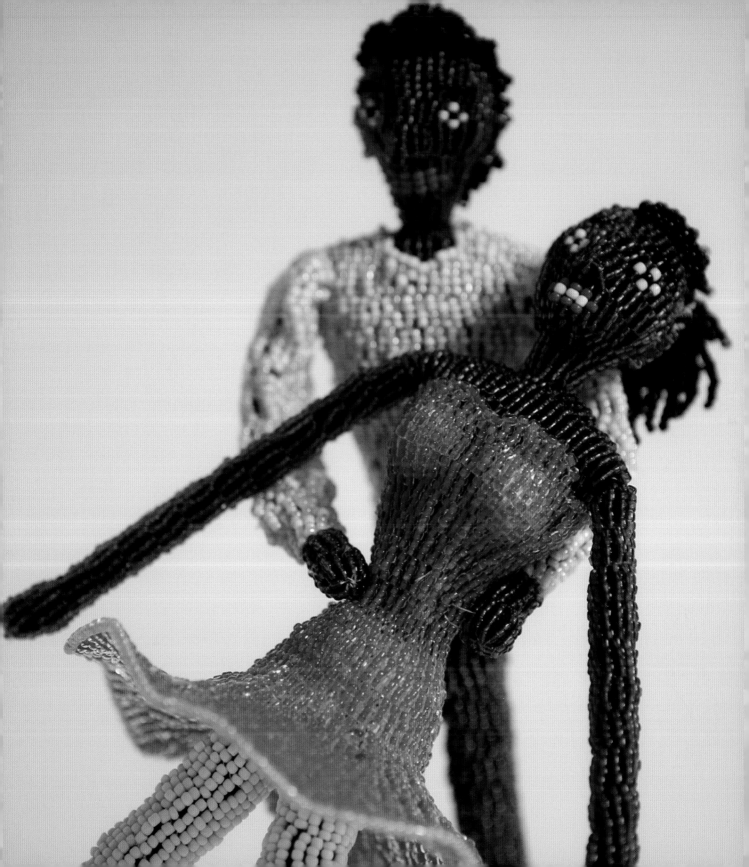

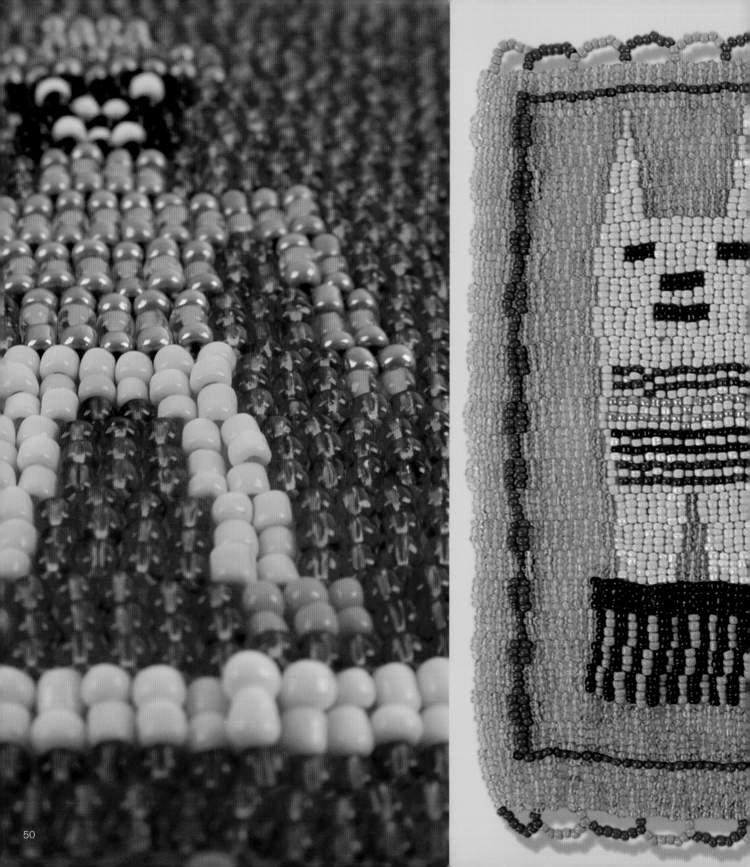

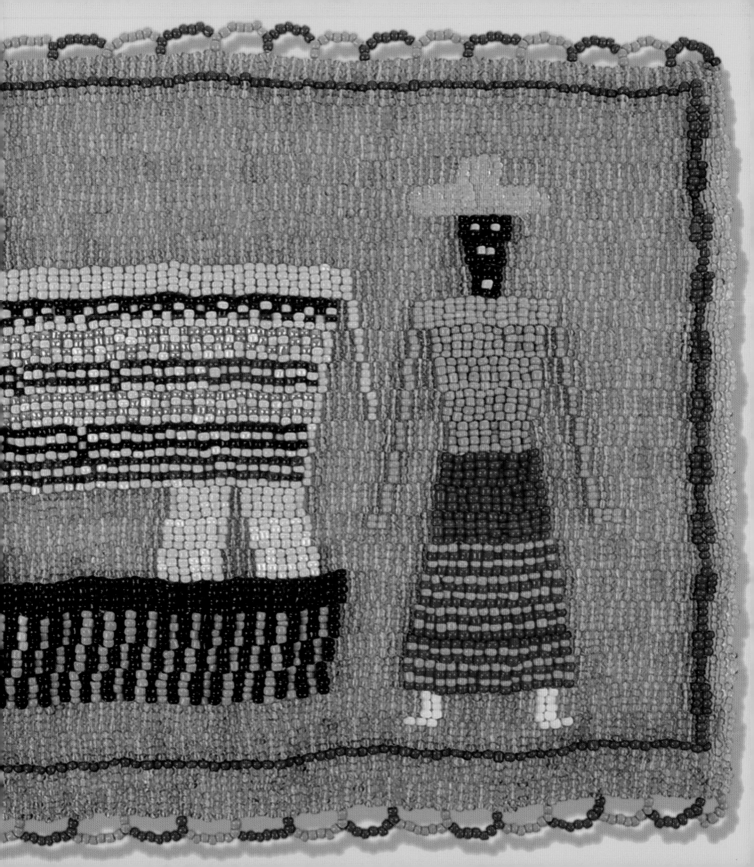

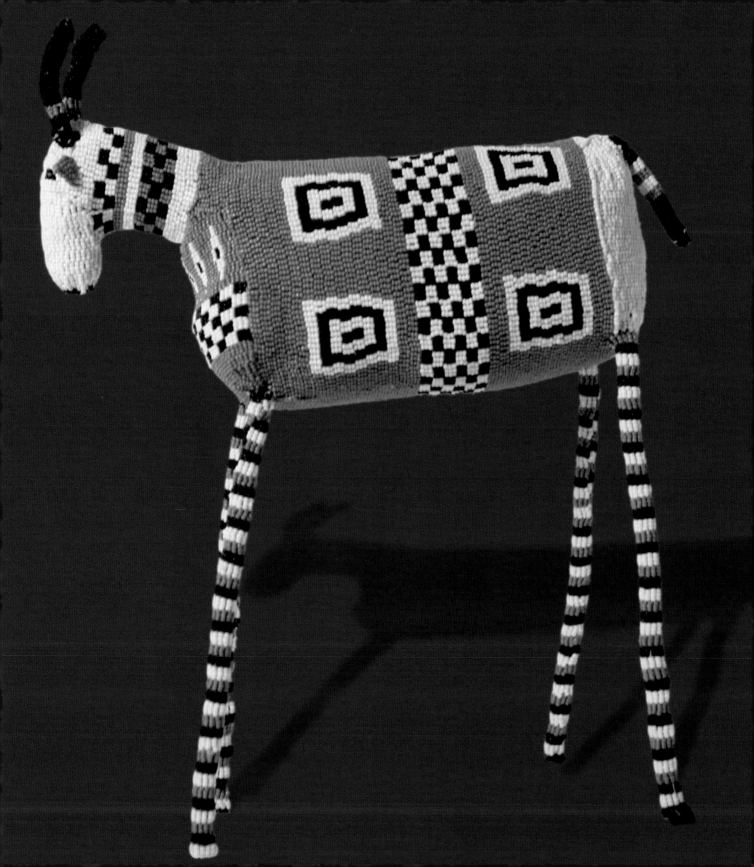

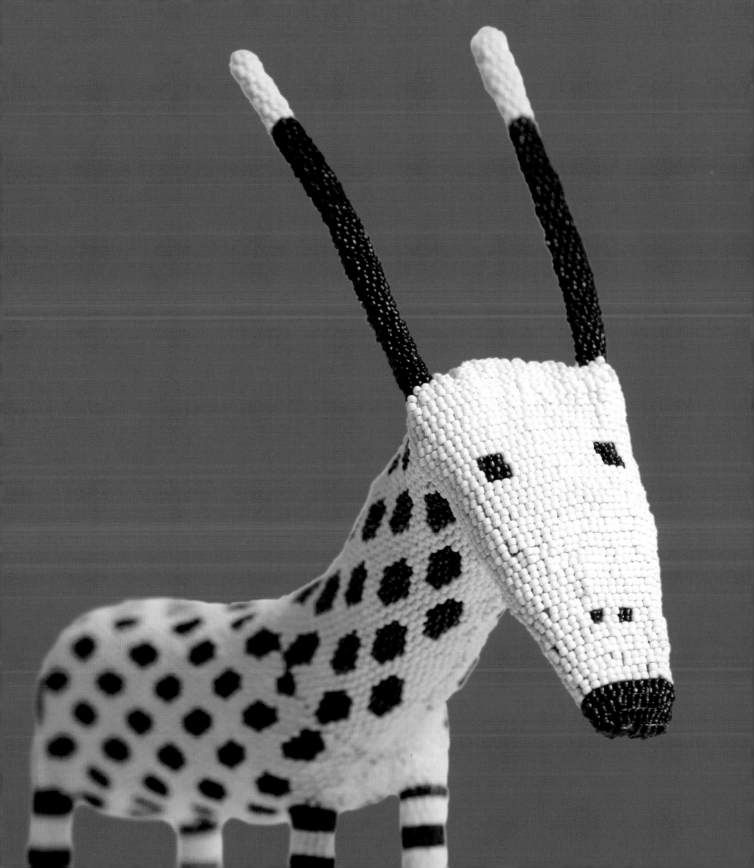

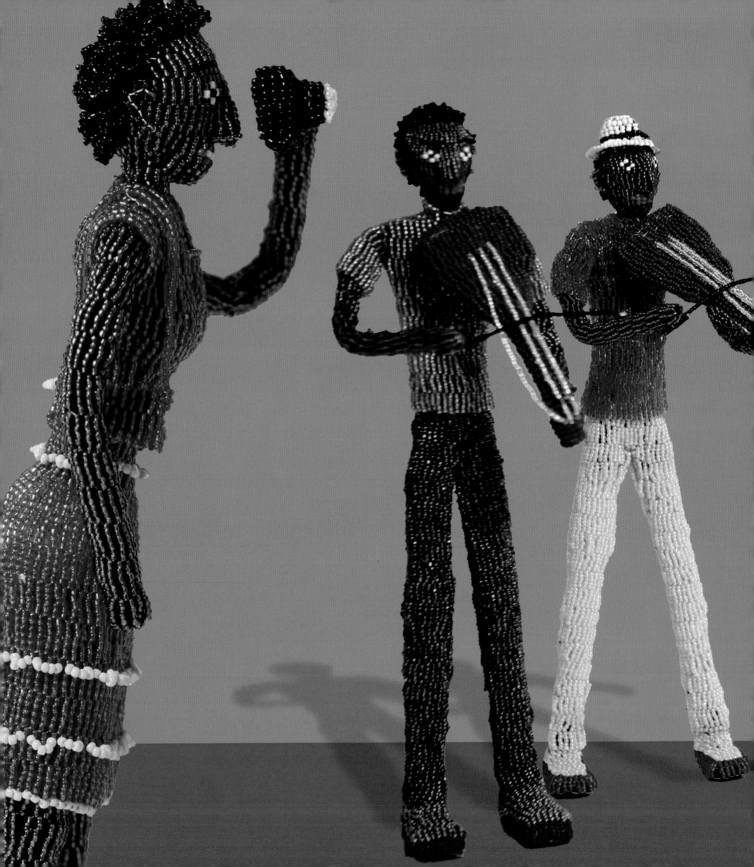

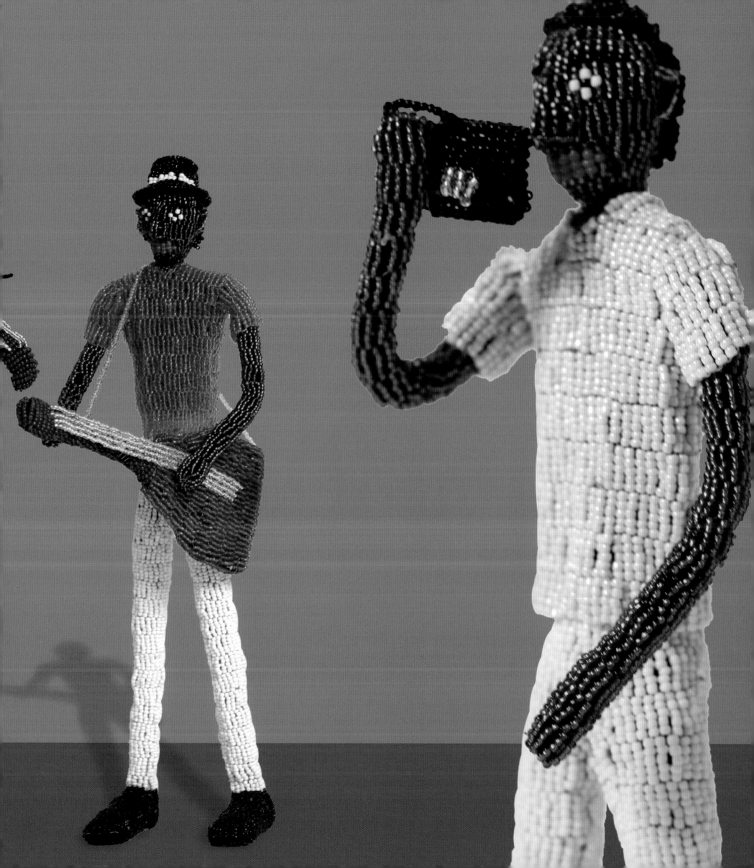

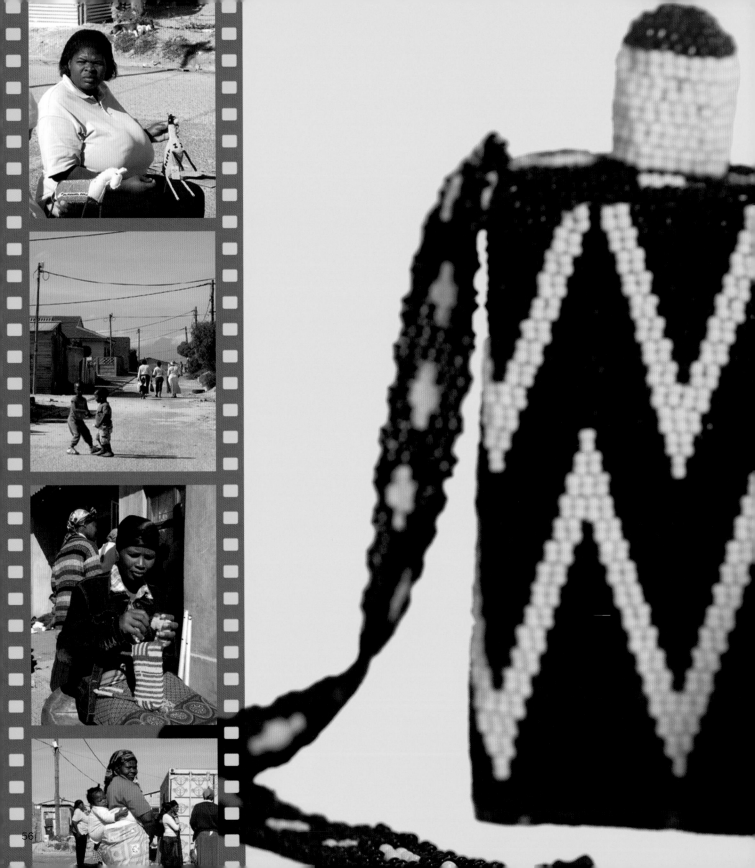

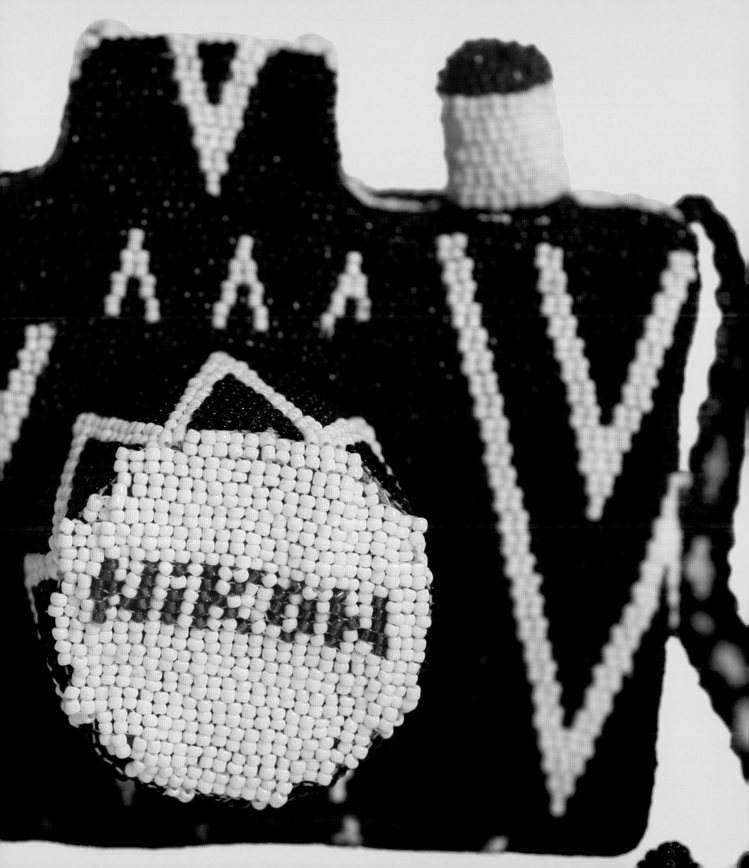

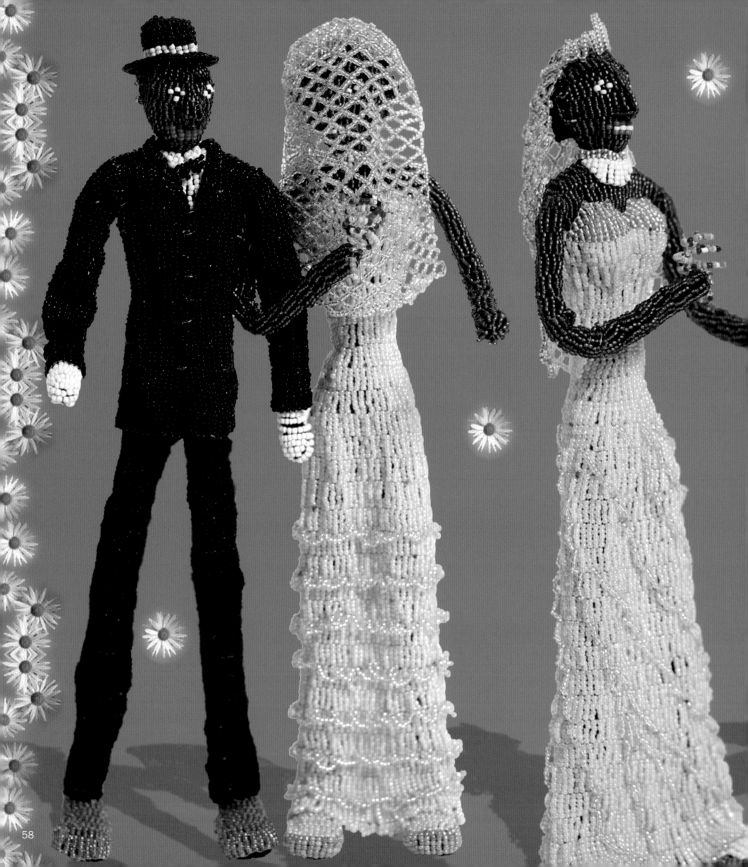

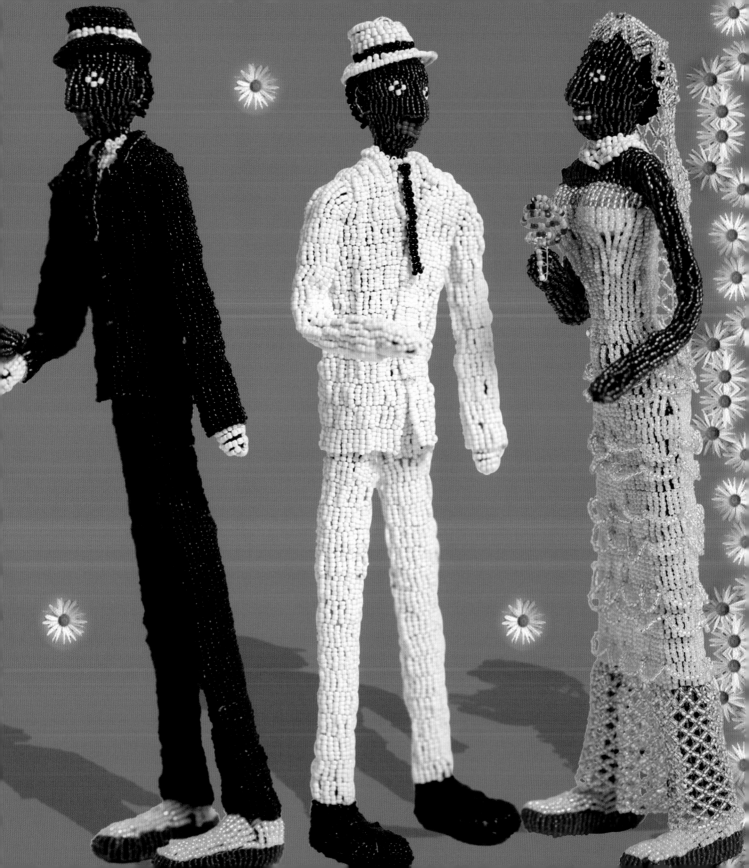

hlala!

***Sit!**

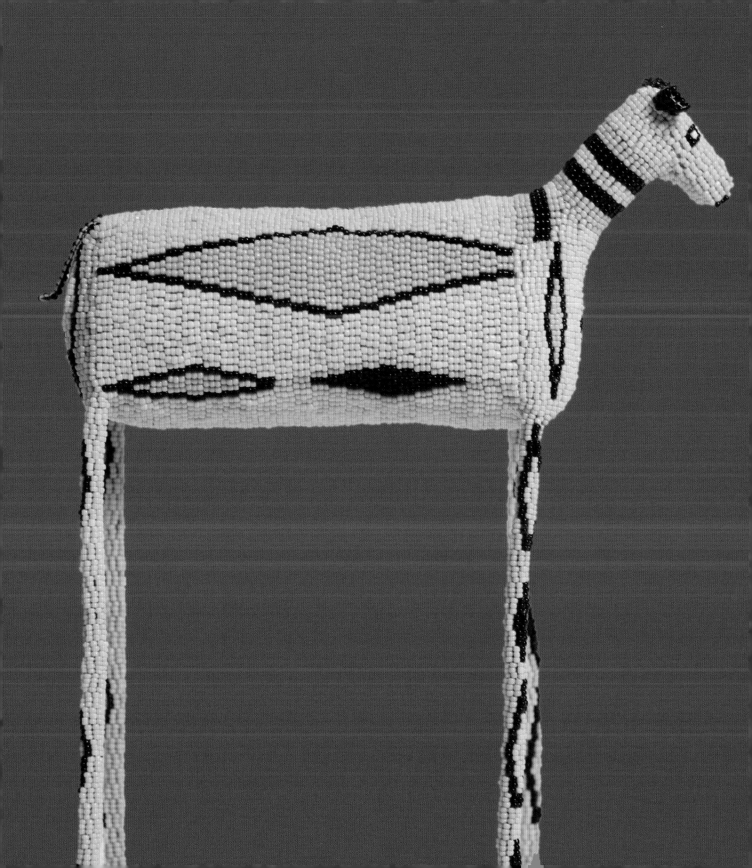

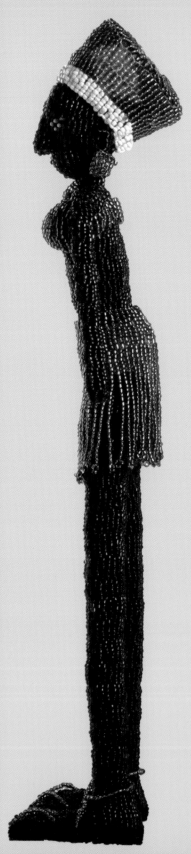

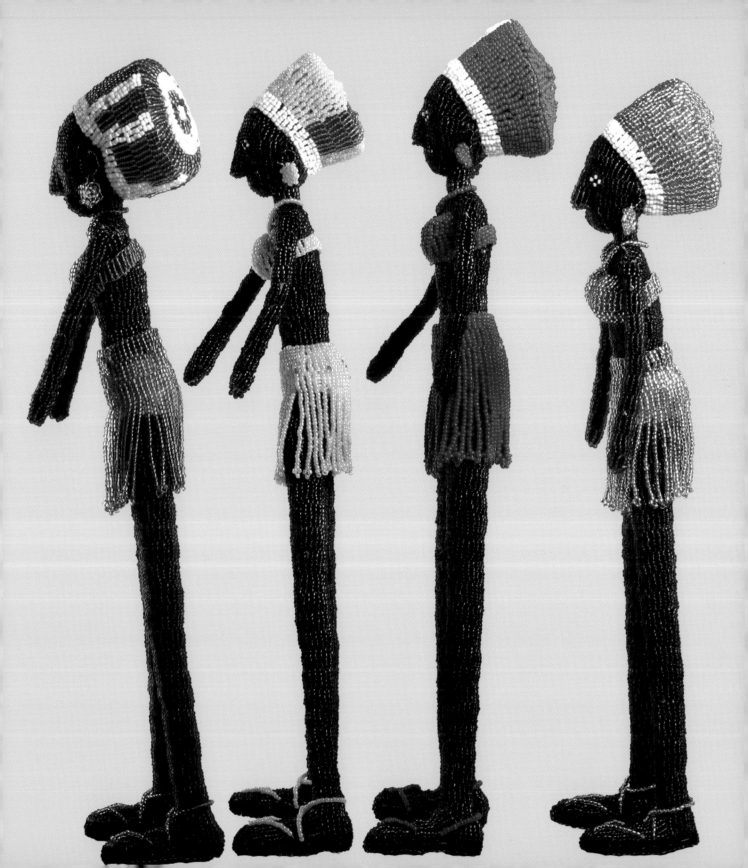

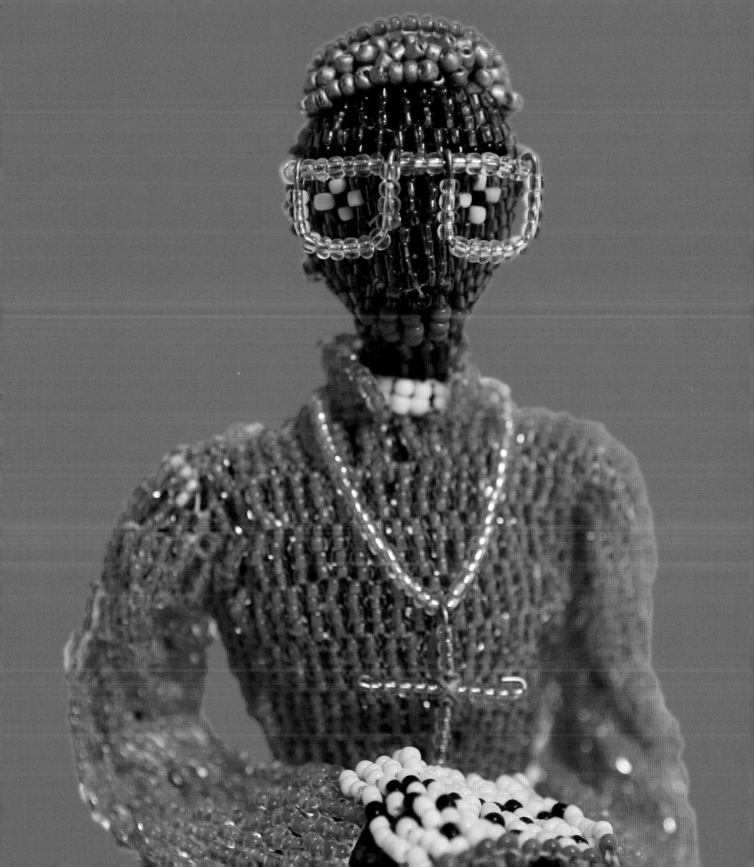

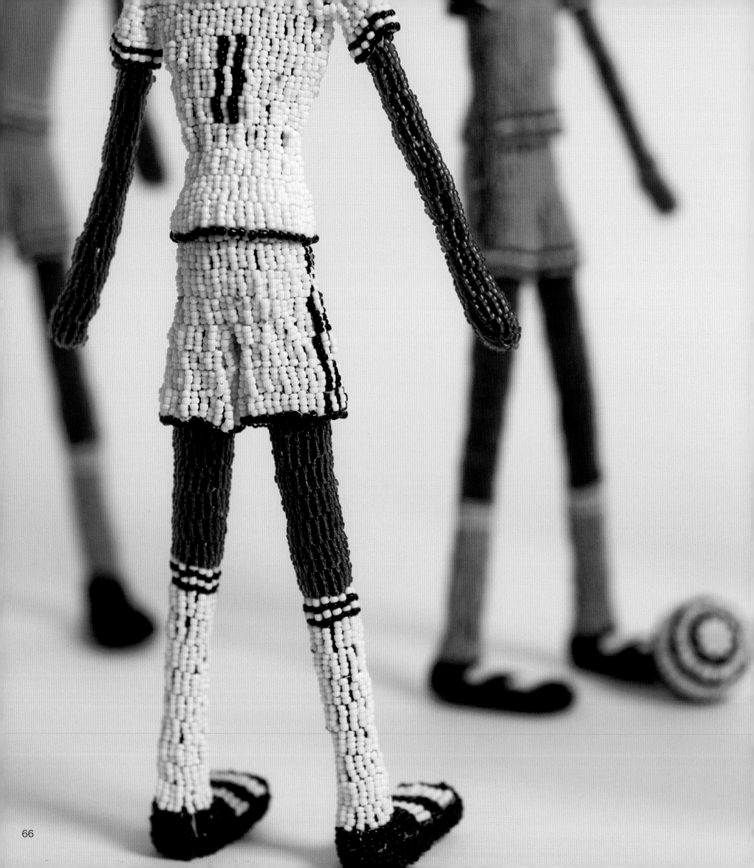

ba
fana
bafana

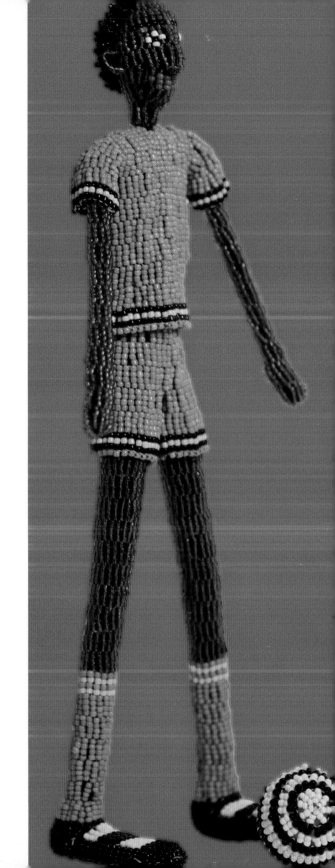

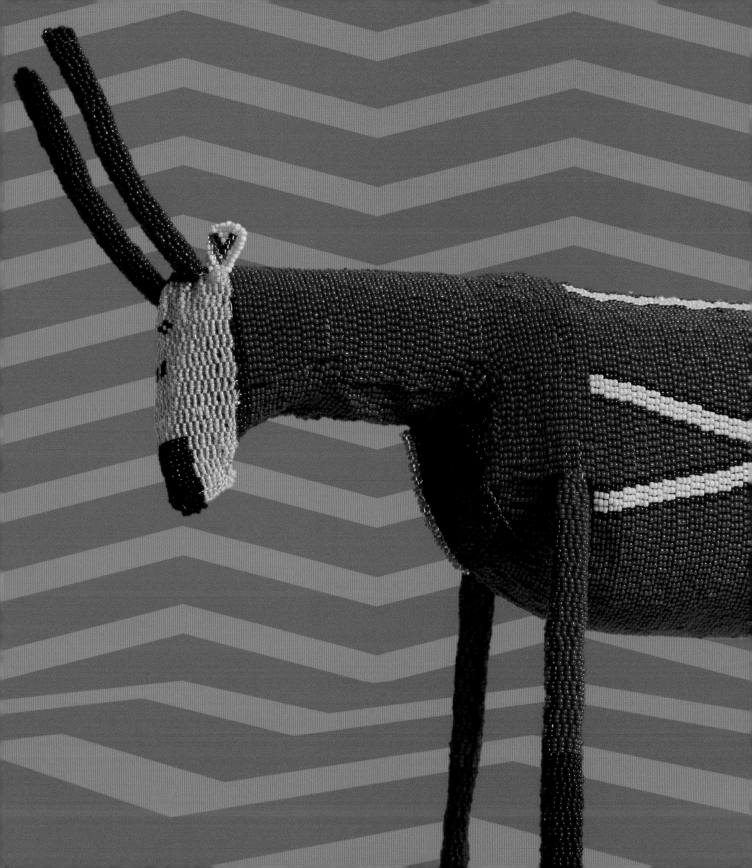

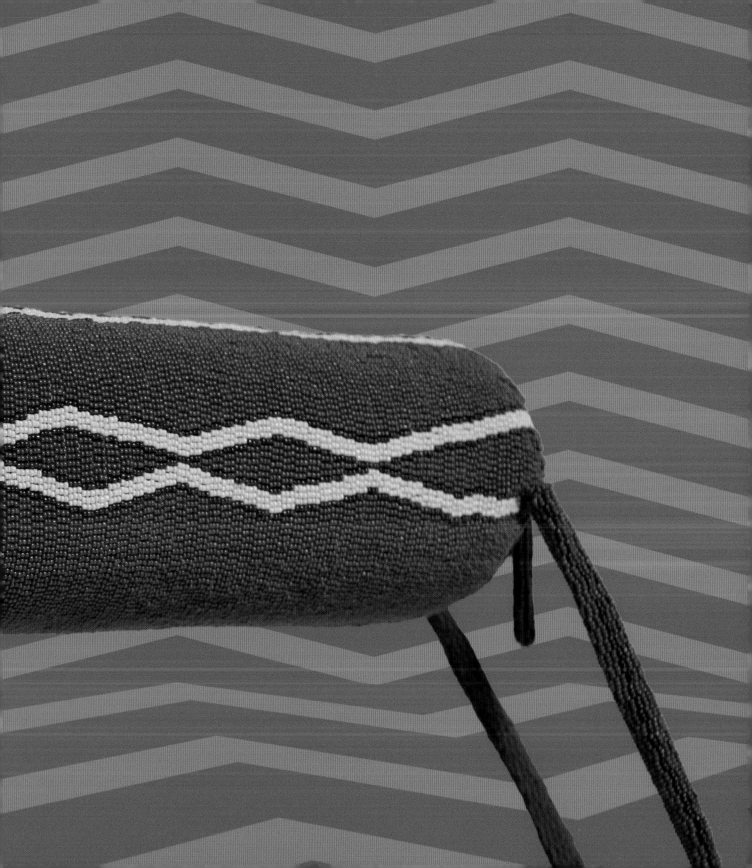

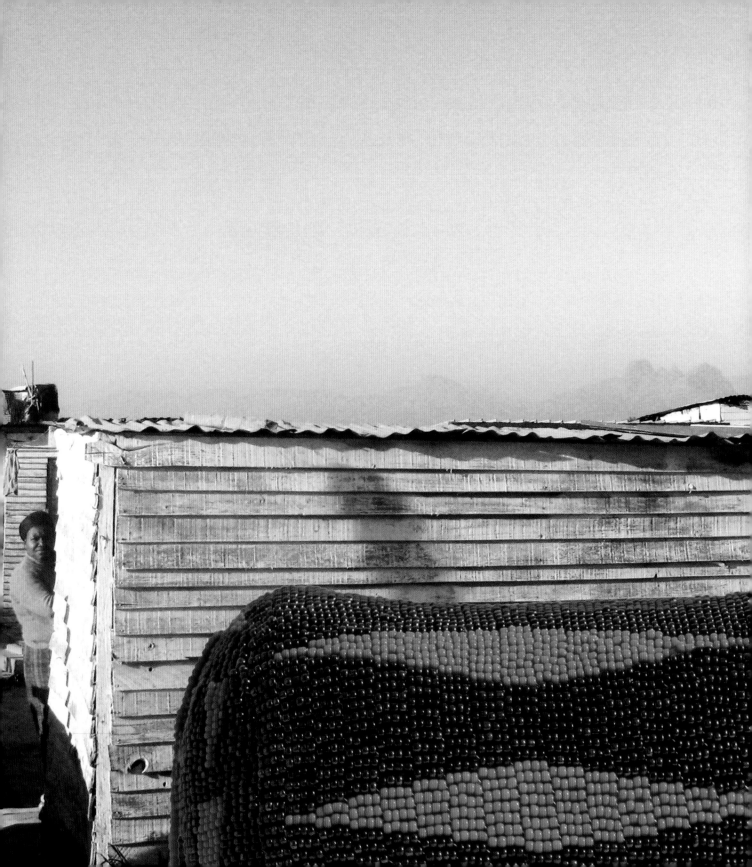

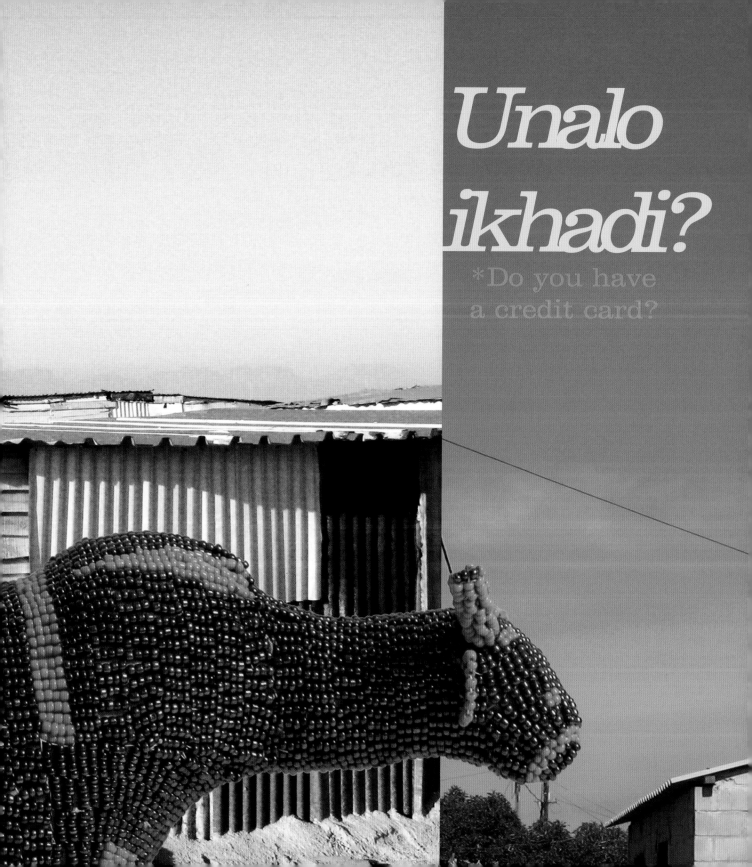

Unalo ikhadi?

Do you have a credit card?

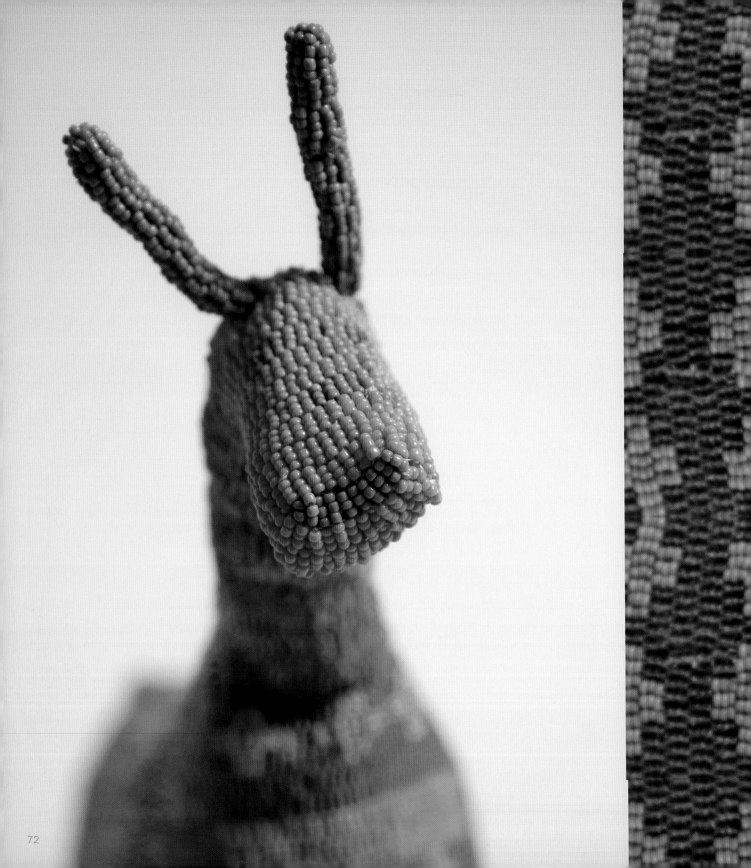

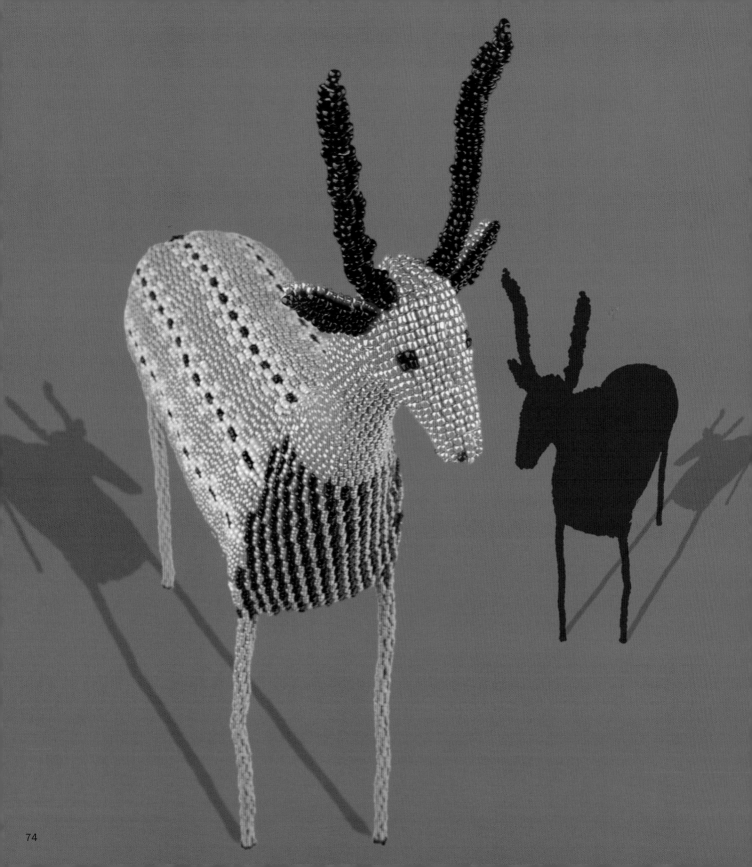

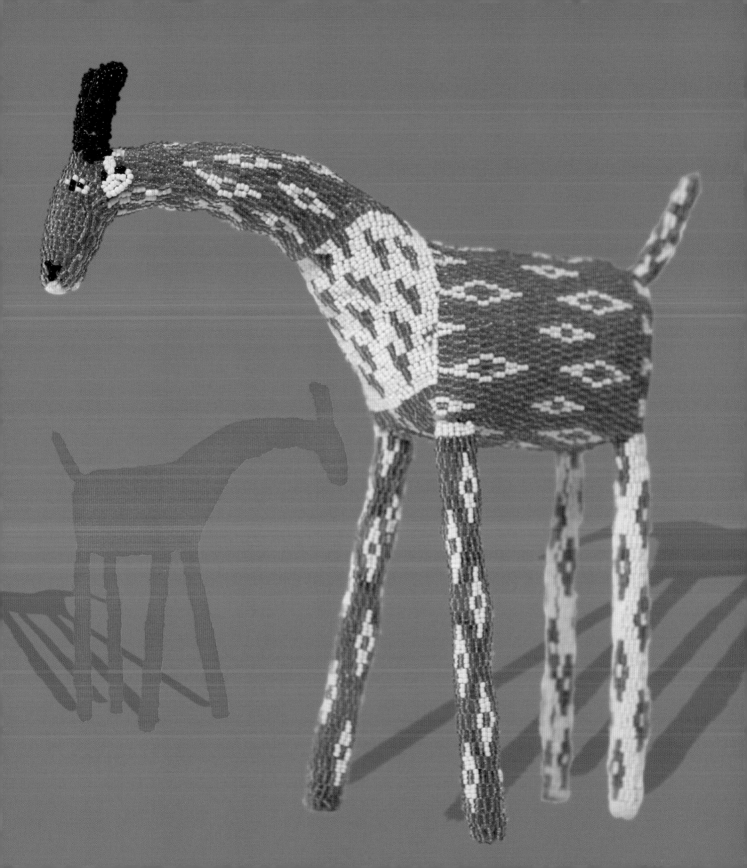

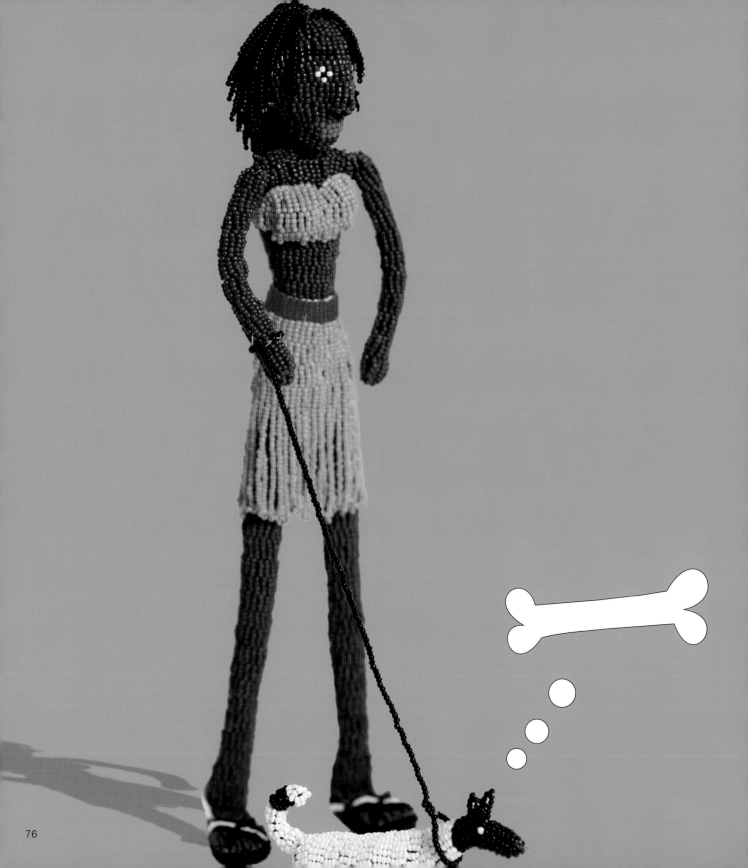

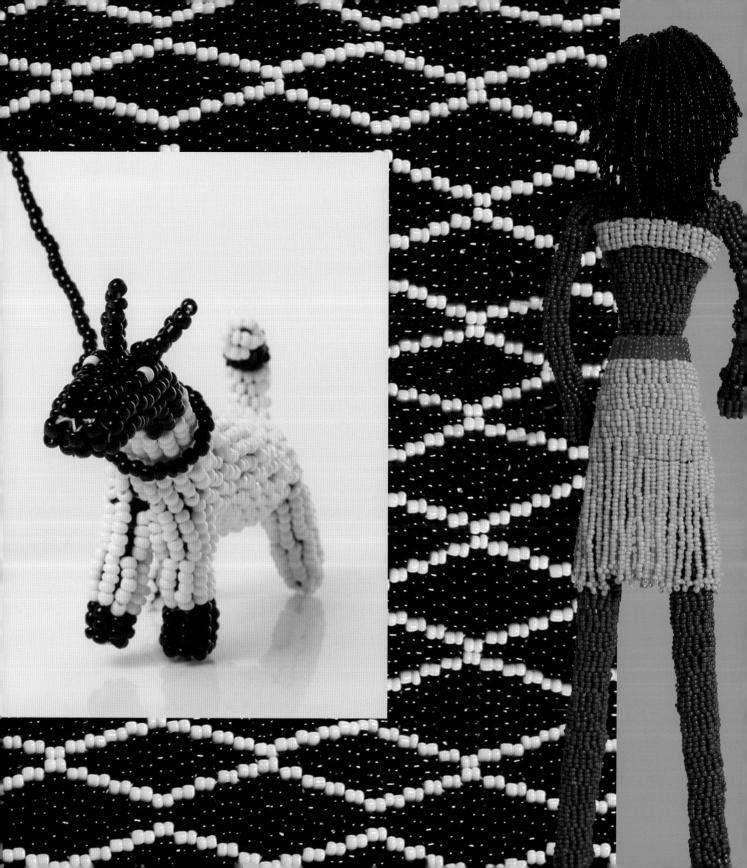

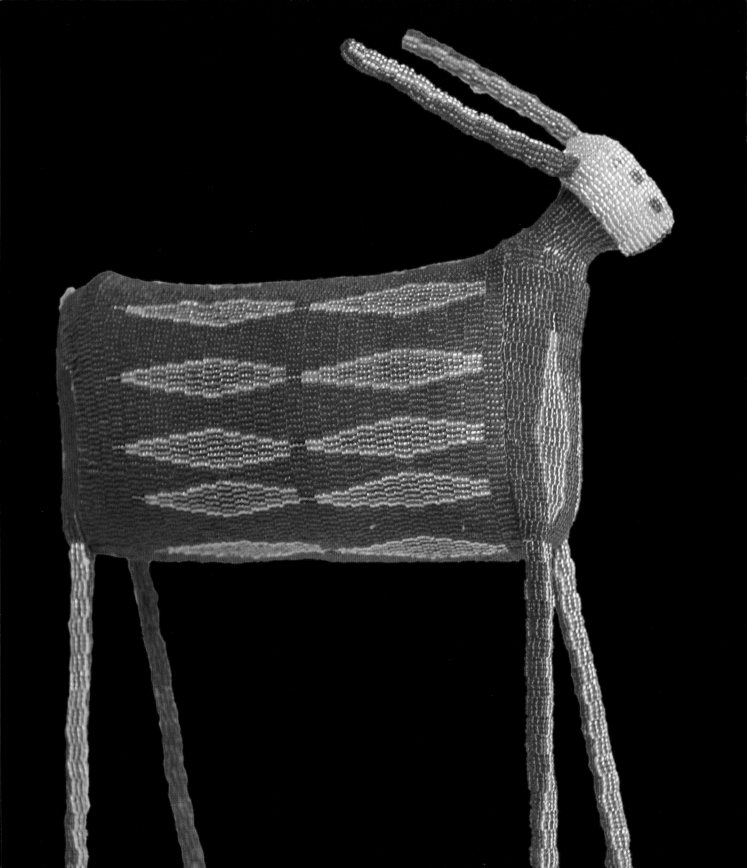

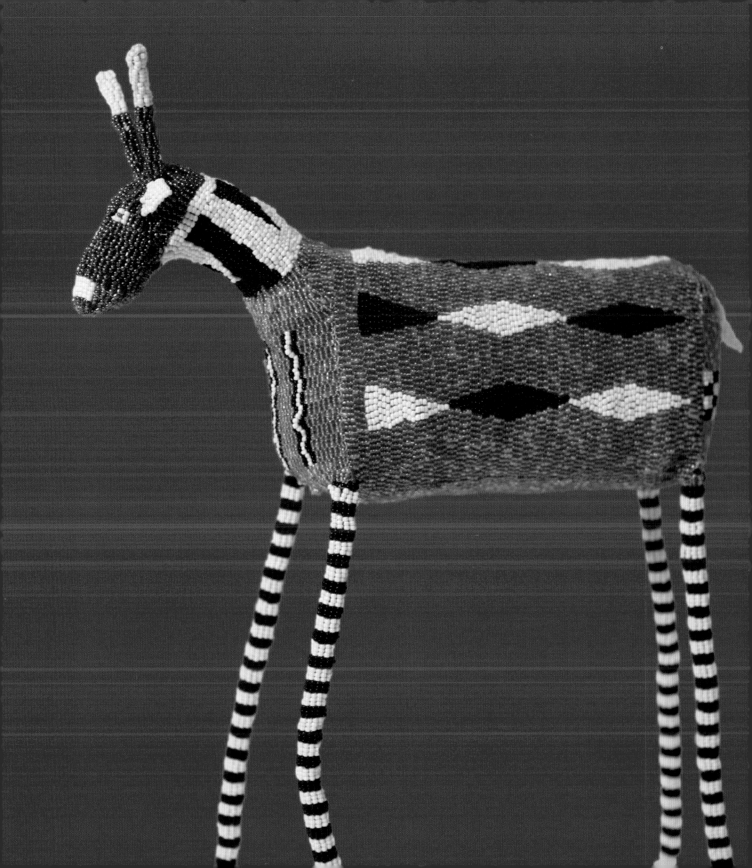

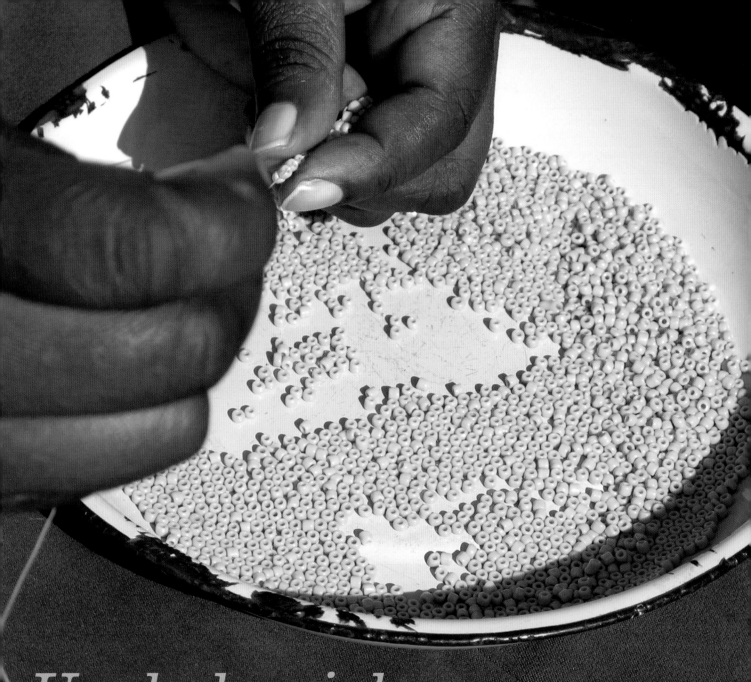

Uqala kanjalo wonke umsebenzi omhle wezandla

*How every beautiful artwork begins

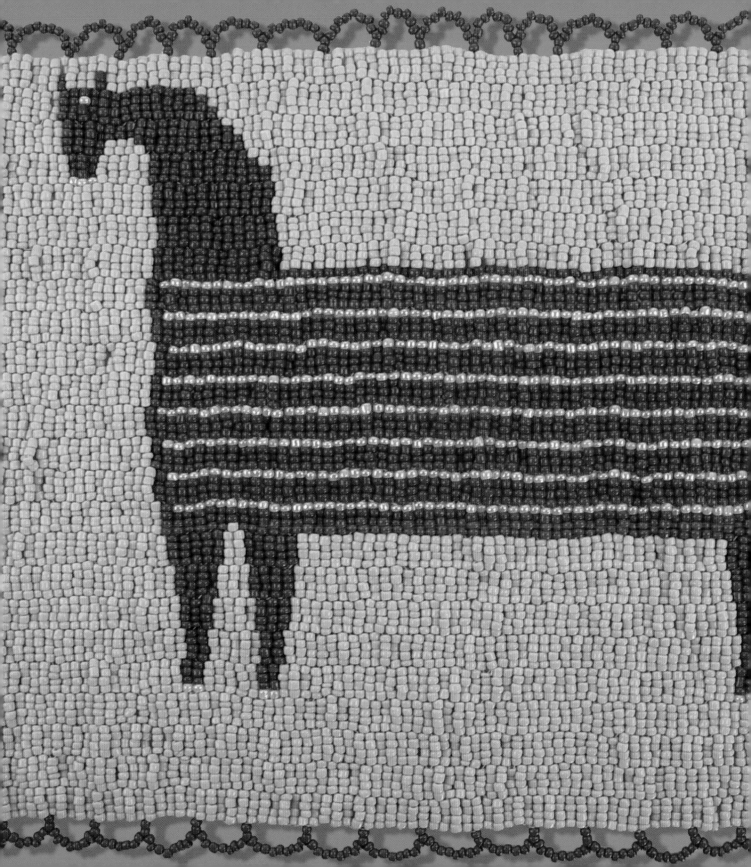

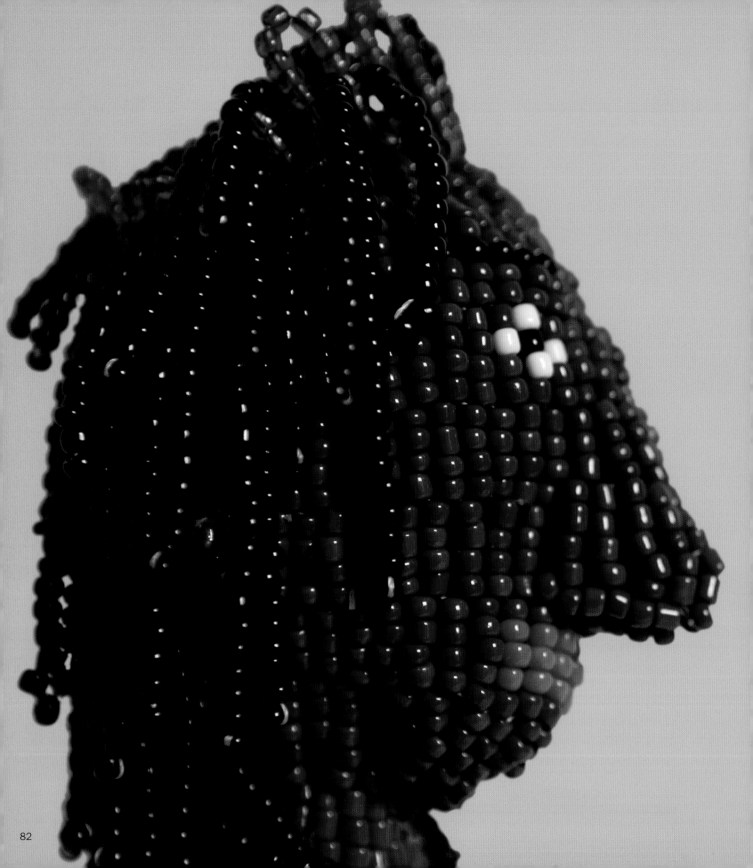

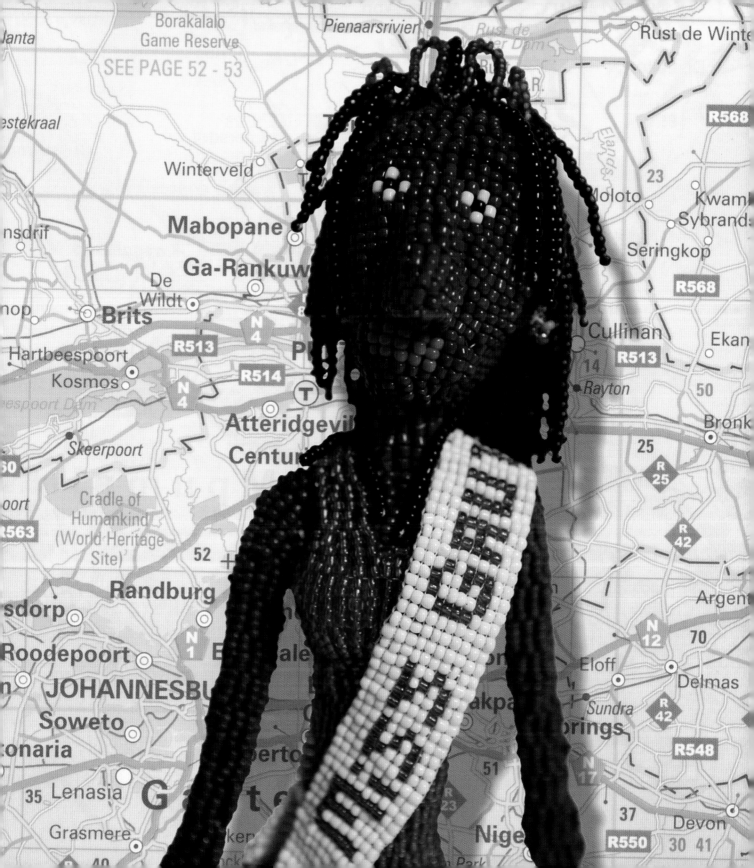

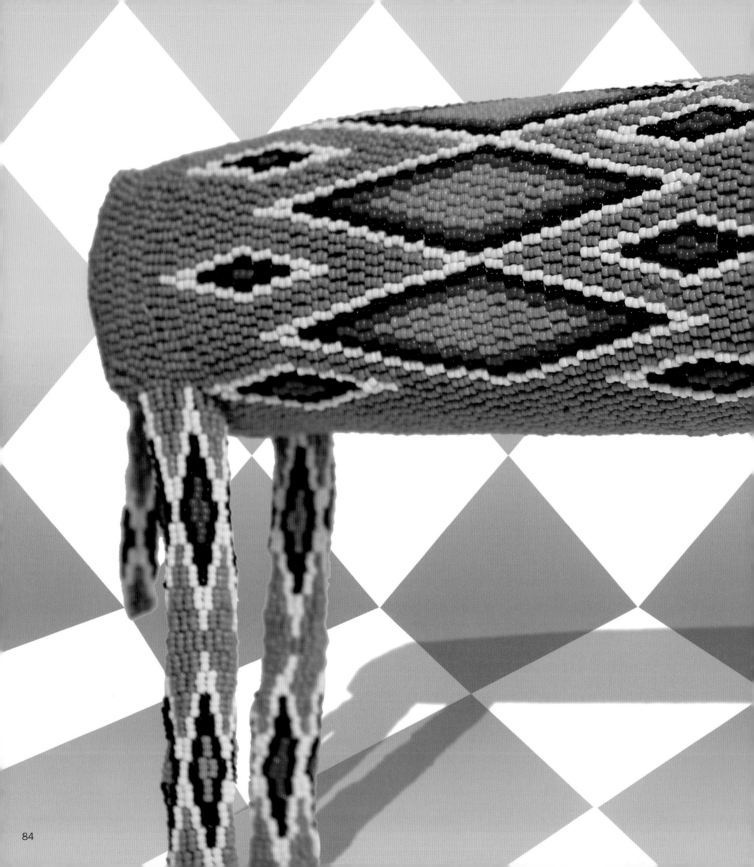

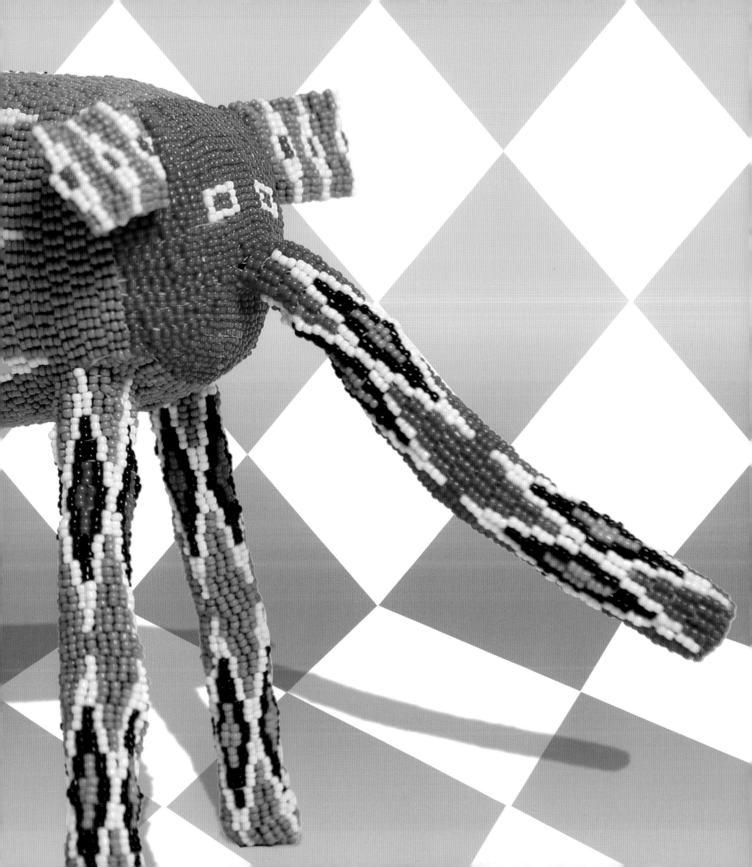

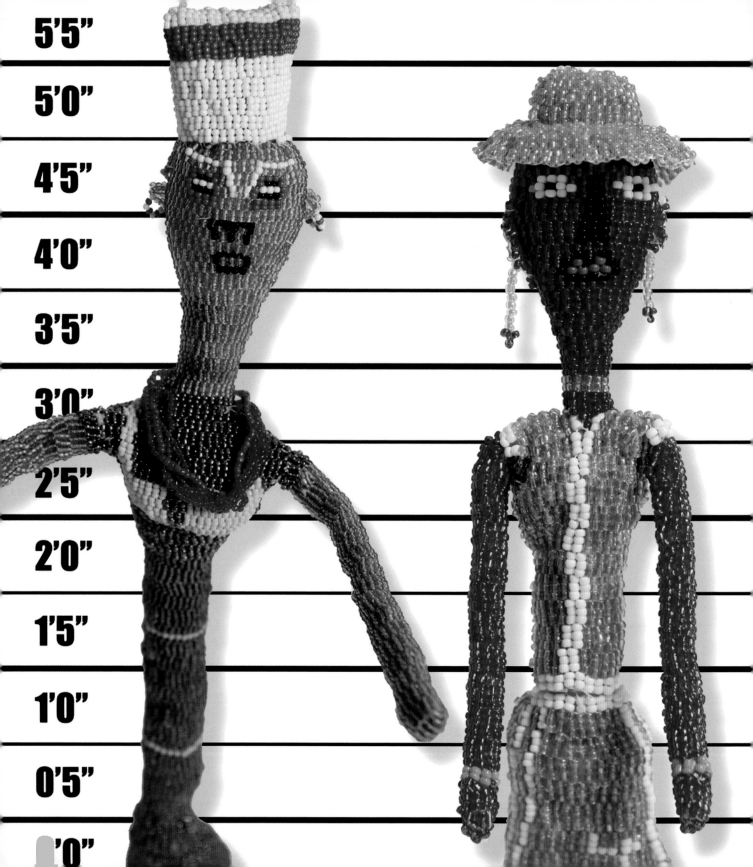

5'5"
5'0"
4'5"
4'0"
3'5"
3'0"
2'5"
2'0"
1'5"
1'0"
0'5"
0'0"

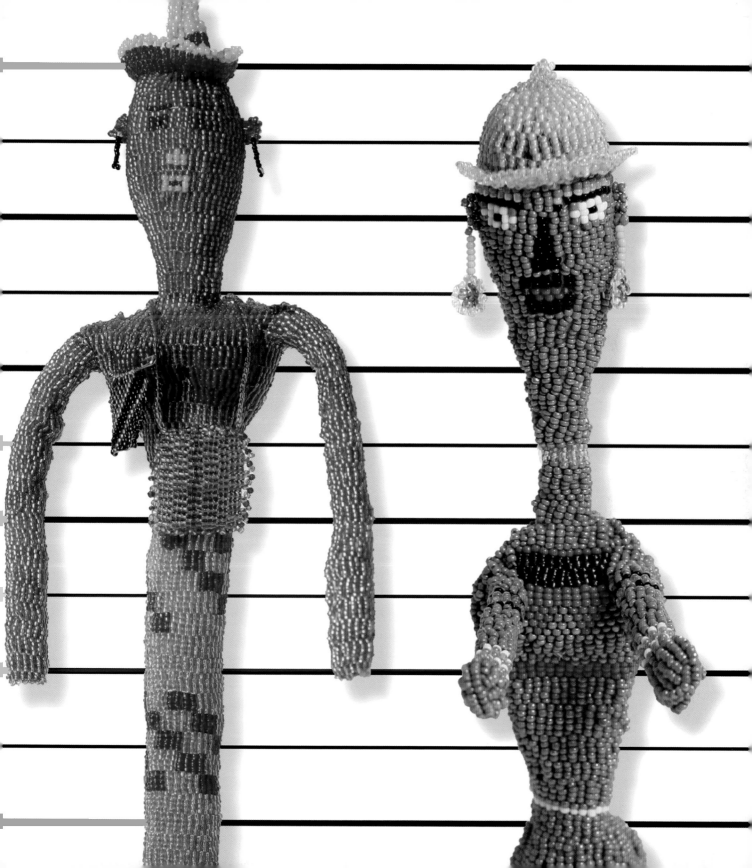

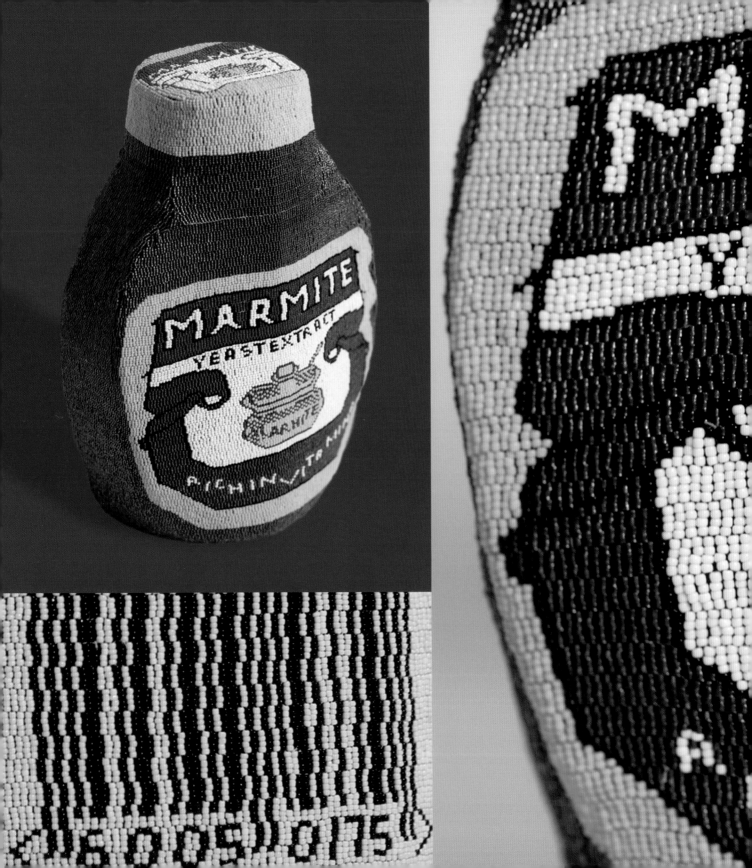

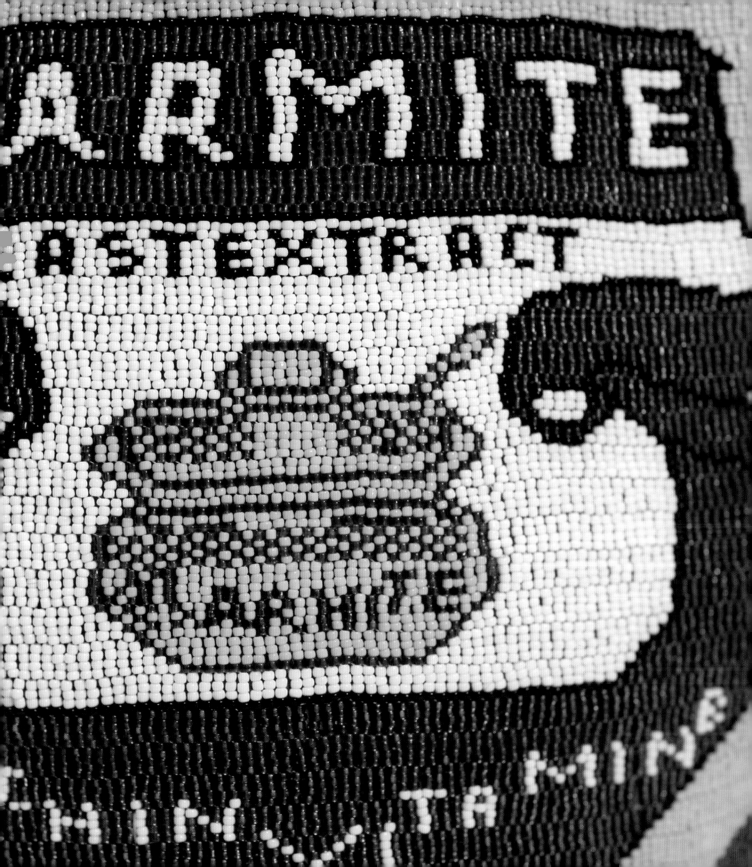

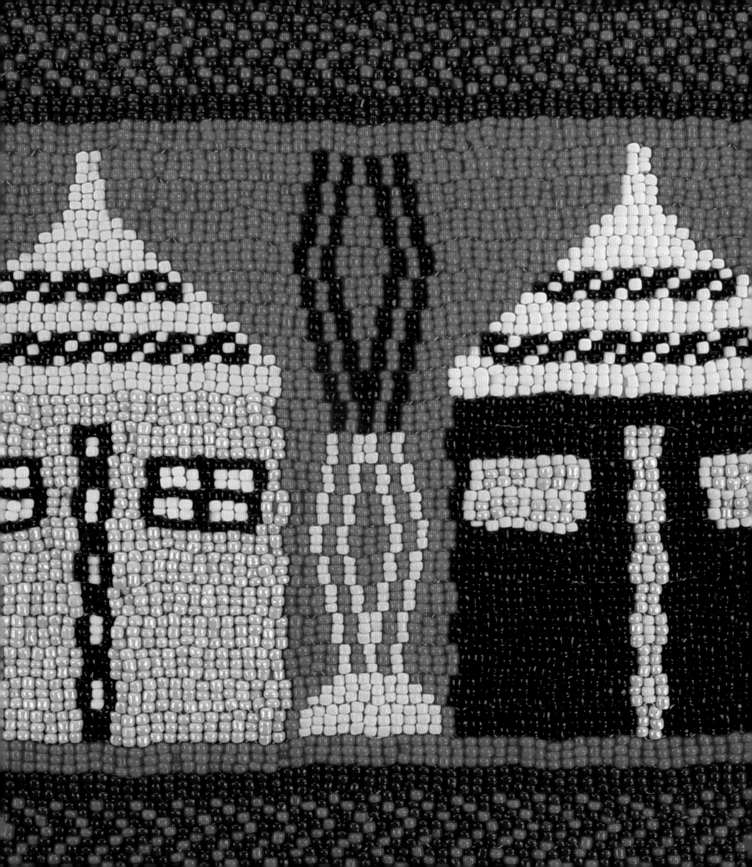

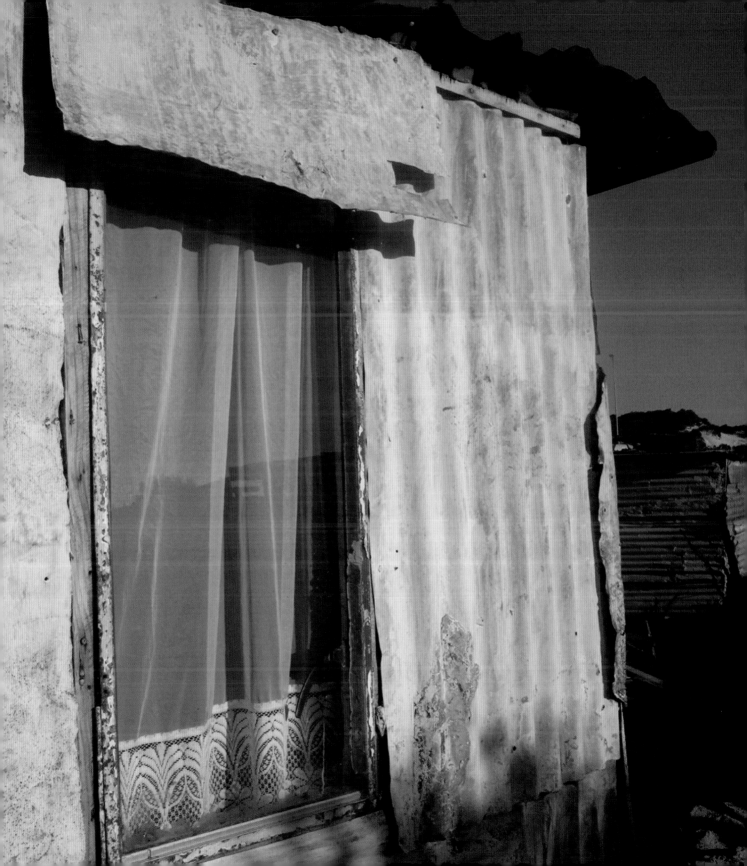

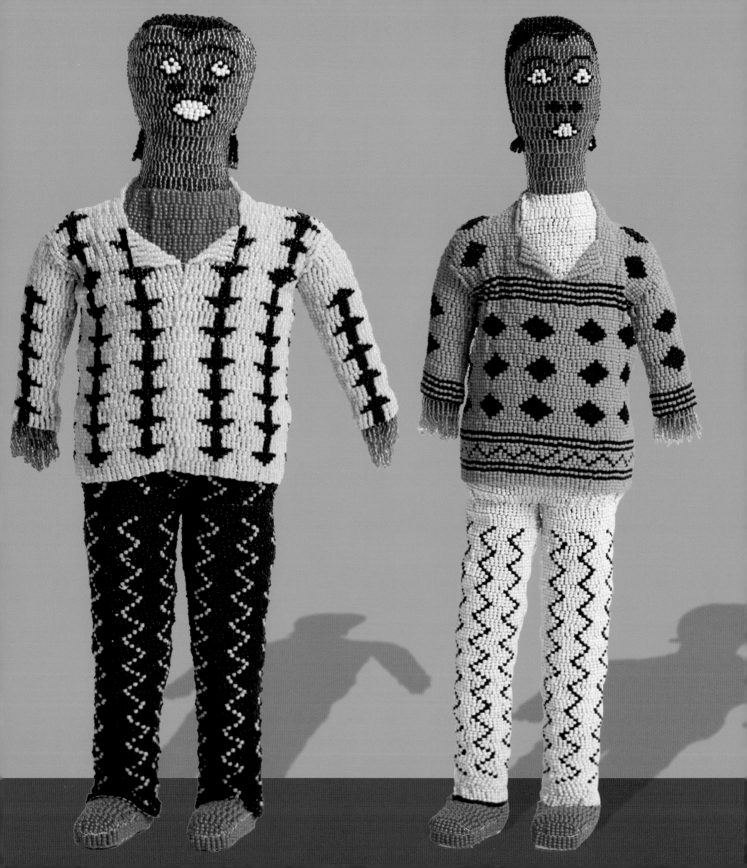

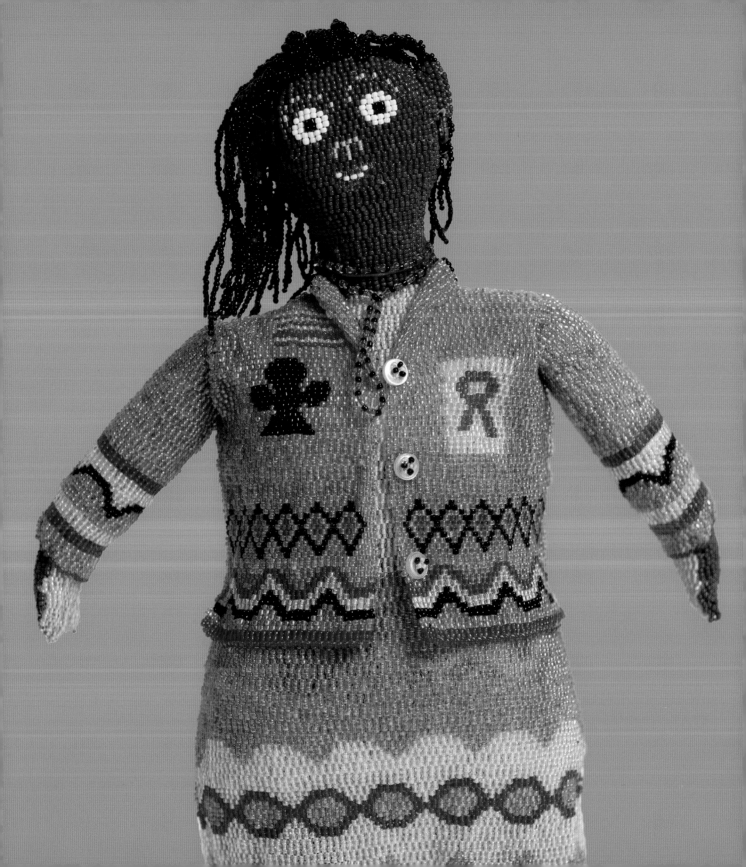

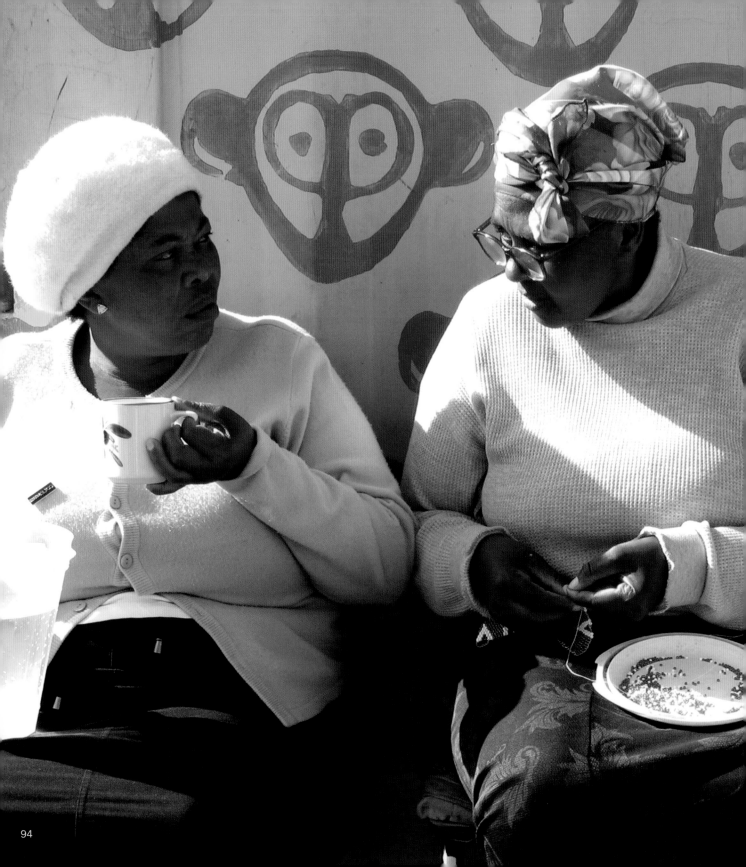

You've read about the pioneering collective achievement of Monkeybiz. You've seen the gorgeous multi-coloured artworks showcased in the gallery. Now meet some of the leading Monkeybiz bead artists whose individual brilliance is astounding. Their personal narratives are interwoven in the rich fabric of the Monkeybiz story; the project would not have made such enormous strides without their enthusiasm, perseverance and ingenious creative ability.

the artists

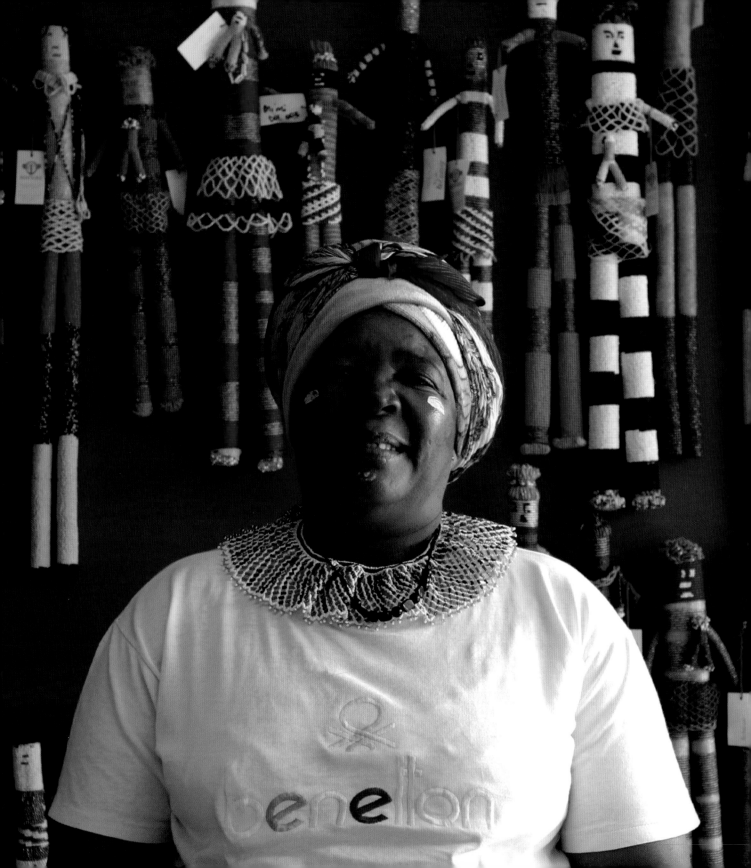

mkafareli
dawethi, age 59

When Mkafareli was young she watched her mother doing traditional Xhosa beadwork. She had to relearn the art of beading with Monkeybiz and is doing it as though she had never forgotten it.

"I'm so proud my dolls go overseas. It's good to know other people like what I do and that the dolls look good in their homes."

Mkafareli's large dolls are distinctive because they often have babies strapped to their bodies, reflecting an African tradition. This feisty grandmother, who has worked with Monkeybiz since 2002, supports her daughter and four grandchildren, who all live with her.

"Through Monkeybiz I have achieved things I never thought were possible. I own a spaza shop [a small convenience store]. My daughter and grandchildren help me run the shop, so I always have enough time to do the beadwork. My youngest grandchild is 13 and helps me bead the skirts for the dolls. As long as I'm alive I'd like to carry on beading with Monkeybiz!"

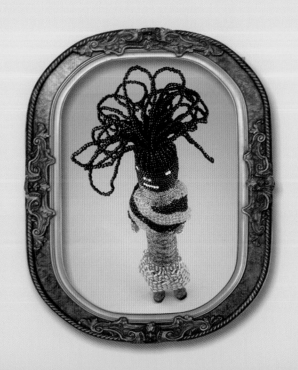

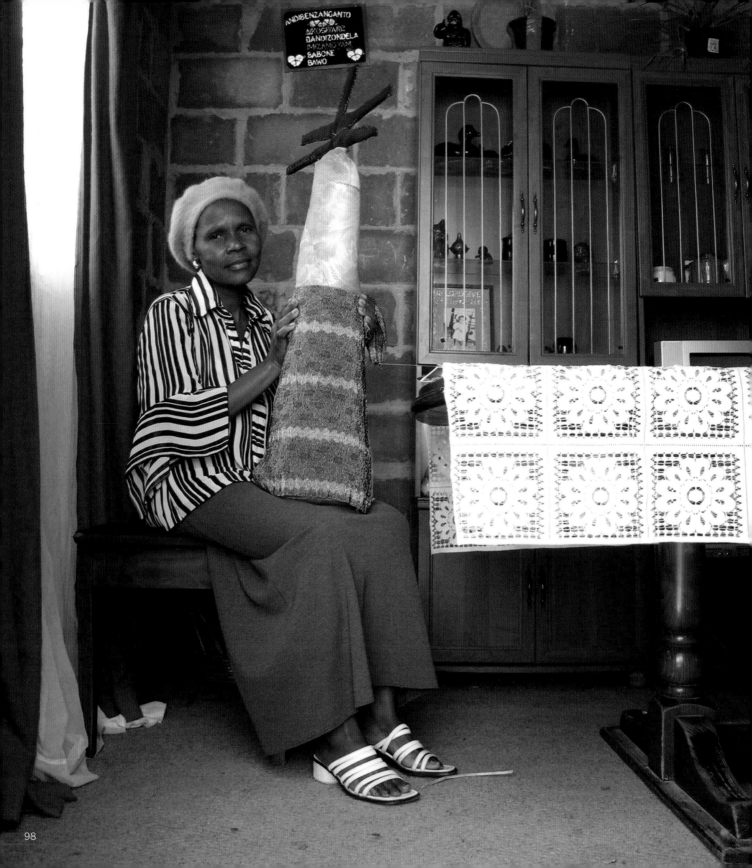

nosakhele

nhahna, age 42

The highlight of Nosakhele's career as a bead artist – she has been with Monkeybiz since its inception in 2000 – occurred recently when she appeared on South African television for an arts programme known as *Head Wrap*. As a result she was commissioned to bead a mural as a backdrop for the stage set of the programme.

Born in Lady Frere in the Transkei, Nosakhele is the matriarch of an artistic family. She has four children, some of whom help her with the beading while others are pursuing careers in acting and singing. Even her husband Boyisile has made his mark as a beadwork artist. He has created a coffee-table-sized beaded Lion Matches piece, a beaded Marmite pot the size of a side table, and a minibus taxi. The last earned him a prize and entry to a national arts competition sponsored by a large South African financial institution.

"Beading has become part of our family life," says Nosakhele. "I can't imagine what we would do without it. **I feel very happy when I do creative work with all the people I love around me."**

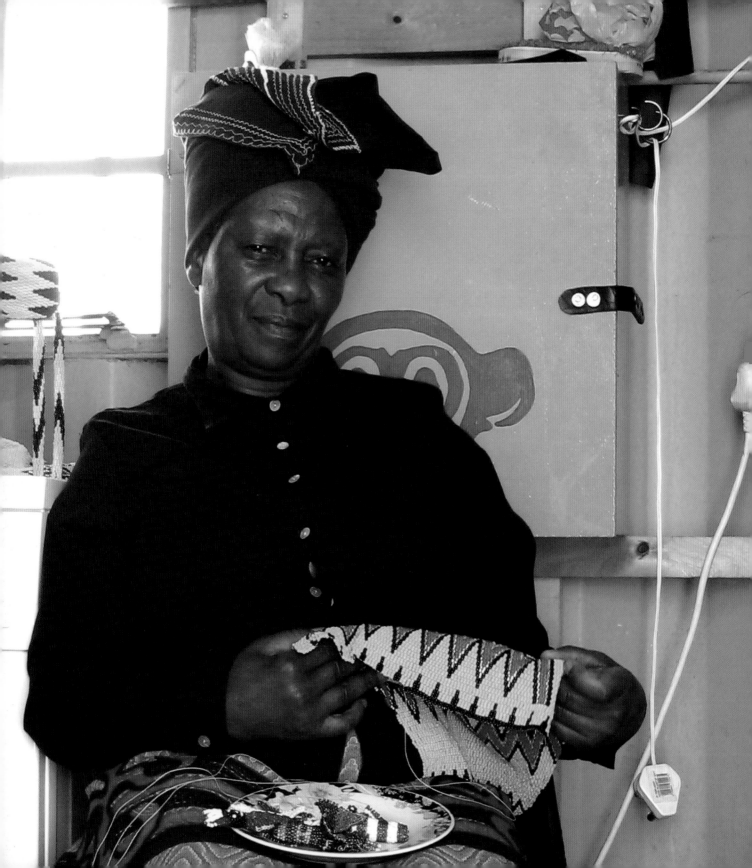

makatiso
ngaka, age 60

Of the 450 people working with Monkeybiz, every fourth or fifth woman will credit Makatiso with having taught them the secrets of contemporary beading. She came to Cape Town in 1988, originally doing domestic and volunteer work. "In those days I could not help noticing the shortage of food and the dire poverty that my neighbours endured," she says.

A devout Catholic, she often prayed to God to help her people find a way to feed themselves. **"Deep in my heart, I feel Monkeybiz is God's answer to my prayer!"**

Born in Makgwaseng, a village near Mount Fletcher in the Transkei, Makatiso watched her mother and aunt beading when she was young. One of Makatiso's proud creations from this period is a sophisticated Sotho traditional skirt known as a *thithana* (see page 20).

Makatiso's beading skills helped launch Monkeybiz in 2000 and she creates anything from complex samples to animals and dolls. Over the years, she has featured in almost all the important Monkeybiz initiatives. Her singing was recorded on a five-track CD released with the *Positively HIV*

book published by Monkeybiz in 2003. Later that year, in the highlight of her career, she represented Monkeybiz at an exhibition and concert to celebrate World Aids Day in Oslo, Norway. Accompanied by Eunice Mlotywa, she presented Mette-Marit, Crown Princess of Norway, with beaded angels as gifts.

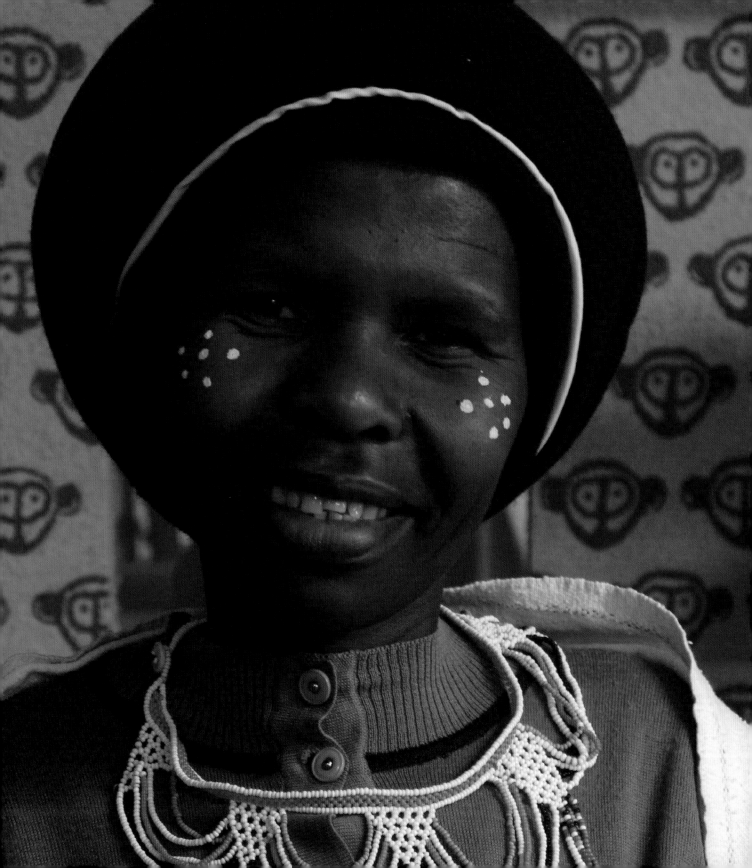

eunice
tema, age 53

Although it takes Eunice roughly three weeks to bead a giraffe that stands nearly 1 m tall, she humbly says, "Oh, there's nothing to it!" But she concedes that such a large piece requires a lot of concentration. "You need patience and focus. Once I've matched up the colour combinations and have worked out the pattern, I do the beading on a flat surface, then drape it across the padded frame. It's just like fitting a skin."

Easier said than done, of course. Eunice's favourite pieces are of elephants, whose large body surfaces show the intricacy of her beading to magnificent effect. **Why elephants and not any other large animals?** "I just like them, even though I've never seen one in the wild. But they do look so good on TV." Actually, it comes down to a technical issue. "The person who makes the elephant frames does it with precision," she smiles. "It makes my work so much easier."

Eunice lives in Enkanini, Khayelitsha, with her husband and two school-going children; two other kids have already left home and live in the Transkei. She has taken the transition from Xhosa traditional beading to contemporary Monkeybiz craft art in her stride. "It's because my mother taught me how to do it like this –" she takes off her traditional *ibhayi*

(shawl), running her fingers over an elaborate border of beadwork. "I had to adjust to the more contemporary style with Monkeybiz, but the process was easy enough."

Born in Centane, a Transkeian village near Butterworth, Eunice has been living permanently in Cape Town since 2002, the year she joined Monkeybiz. "The money I make from beading helps me very much. My husband is very old and occasionally does a few odd jobs, but it's not enough to feed the family. When I joined Monkeybiz I had no idea we would go this far. It's a miracle."

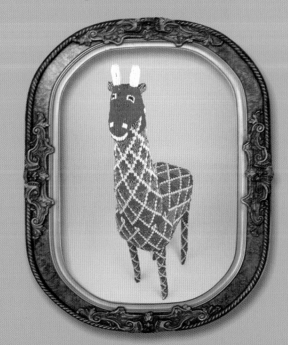

noloyiso
maphakathi, age 40

A gigantic beaded Heinz tomato sauce bottle all but dominates the living-room floor of Noloyiso's cement-block house in Macassar, Khayelitsha. The sheer scale of her work, which includes large dolls, is all the more impressive considering she started out by beading tiny, delicate, little angels.

"I've been with Monkeybiz since 2000," she says. "Before that I was a domestic worker and a farm labourer. My day started at 7 am and ended at 6 pm and my salary was paltry. **These days I'm so grateful to be working from home. I can take breaks when I'm tired and I have enough time to take care of the children.**"

Noloyiso lives with her husband and five children (one of whom is theirs; the rest are her nieces and nephews). Born in Tsomo in the Eastern Cape, her fondest childhood memory is of mixing the dung and cob for plastering the walls of the rural huts where her family lived.

She did not learn beading as a child but was taught by Makatiso Ngaka, a mentor of the Macassar community.

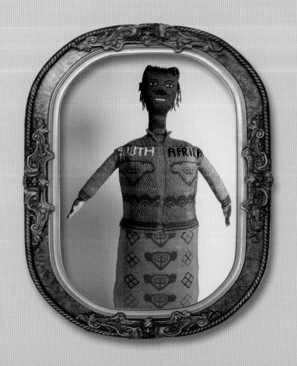

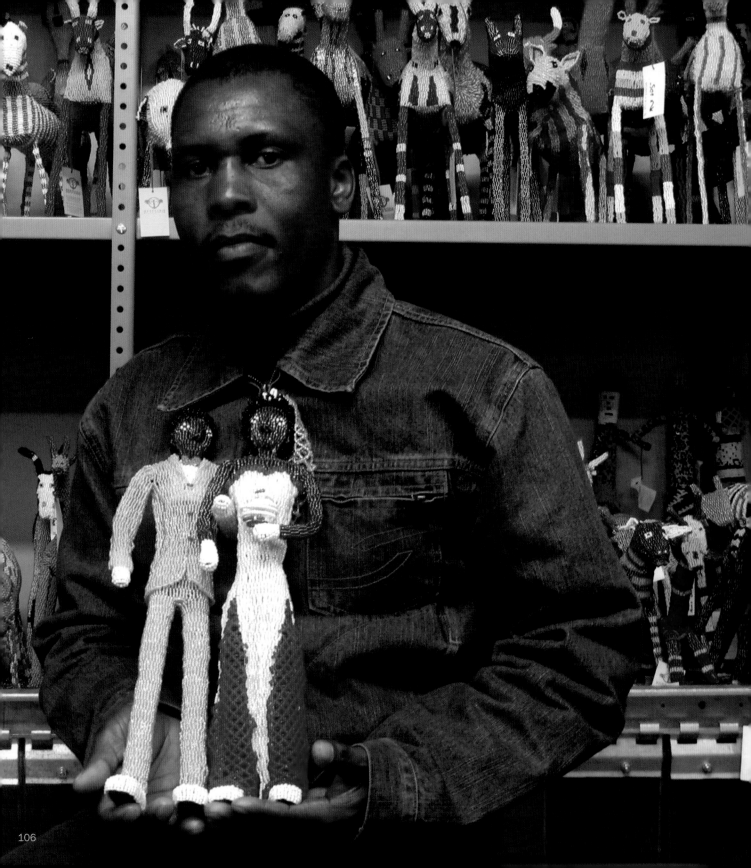

jeremiah moloi, age 38

Jeremiah thinks of his beading skills as "a gift that was in hiding". His grandmother was a sangoma and he credits her supernatural powers for leading him to Monkeybiz because he had asked her to help him find a better job. "I can see now that I can do anything with beads.

"I fell in love with beadwork the day I first saw it. There are new ideas brewing in my mind all the time. I don't notice getting tired when I'm doing beadwork; often a whole day goes by without me feeling the need to stop."

When Jeremiah does beadwork he feels the presence of God. **"The start of brilliance is when you know God, and if what I am doing is brilliant, then God is there."**

Jeremiah was born in Vrede, a small town in the eastern Free State. He moved to Cape Town in 1991, found work as a security guard in 1994 and was joined by his wife and family in 2000. In 2003 his wife introduced him to a friend who was working with Monkeybiz. Without really knowing how to bead, Jeremiah made frames from wire and borrowed the beads from his wife's friend to make two dolls of a traditional Zulu man and woman. He phoned Shirley Fintz – and the rest is history.

In 2004 he quit his job as a security guard to work full-time with Monkeybiz. Jeremiah has returned to Vrede, which he describes as "a quiet place where I can think or write. And it has fresh air so I can come up with new ideas."

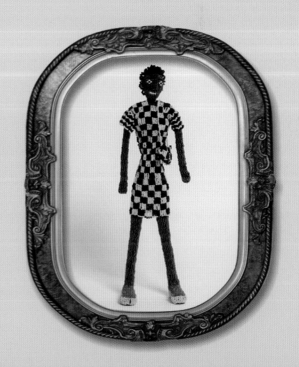

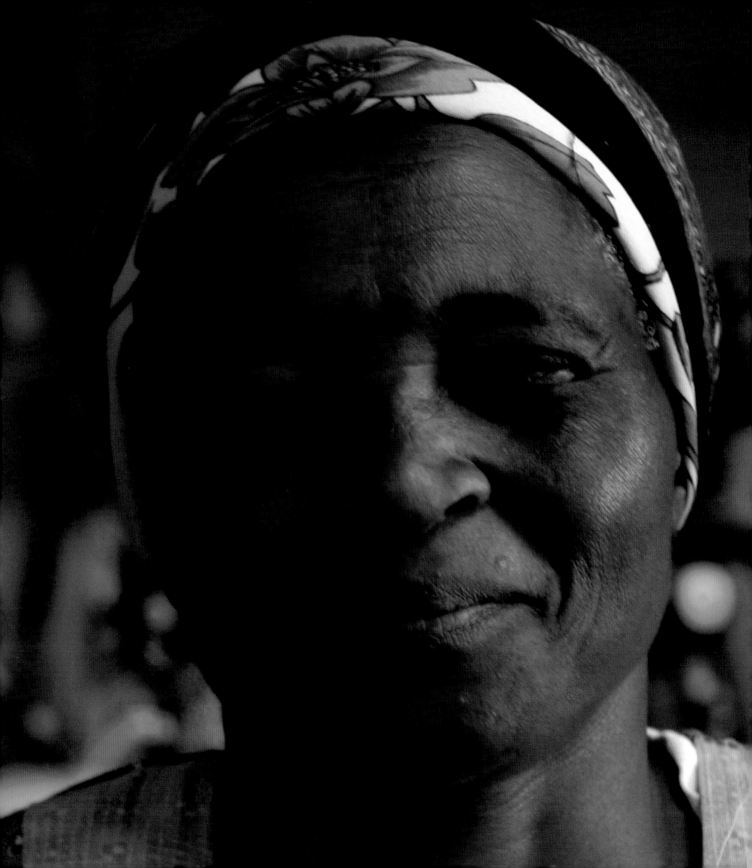

bukelwa
sophazi, age 59

Bukelwa learnt about Monkeybiz for the first time in 2003, when a fellow resident of Samora Machel showed her a marketing brochure. She and her husband care for five children and were unemployed before she joined Monkeybiz. "It has changed our lives," she says. "We can afford to buy clothes, food, send the children to school ..."

Although Bukelwa started out by making angels and dolls, she prefers creating animals with intricate patterns and rich colours. **"I just love animals,"** she beams. "At home I have cats and dogs. And at my rural home in the Transkei [a village called Qamakhwe in the vicinity of Umtata], **I have cows and sheep and goats and horses – you name it!"**

When Bukelwa's family from the Transkei comes to visit her in Samora Machel, they are fascinated by the funky beaded animals she creates with Monkeybiz. Through her art, she maintains a connection to her roots.

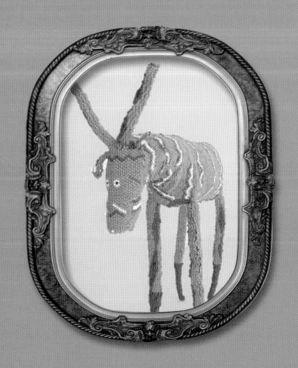

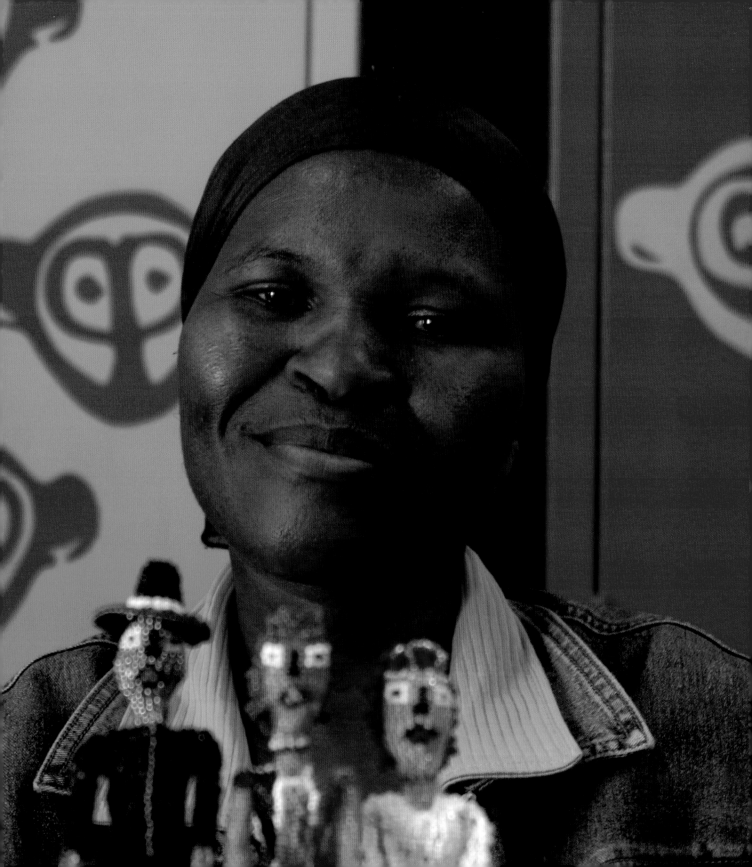

patricia
dlabane, age 39

P atricia never learnt to do beadwork as a child. She was introduced to it by a friend who was already working with Monkeybiz. The two met at church and Patricia trained as a beadwork artist at her friend's house for three months before she registered with Monkeybiz. She has never looked back, distinguishing herself by creating bride and groom dolls that are notable for their unique style and delicate attention to detail.

Born in Tsomo in the Eastern Cape, Patricia moved to Cape Town in 1993. She and her husband support three children, and both were unemployed before starting with Monkeybiz in 2005.

"My life has improved so much," she says. "Nowadays when I need to borrow money from friends it isn't a problem. They know I'll pay them back because I earn an income. And because of the **Monkeybiz burial fund I know I'll be able to give members of my family a dignified burial.**"

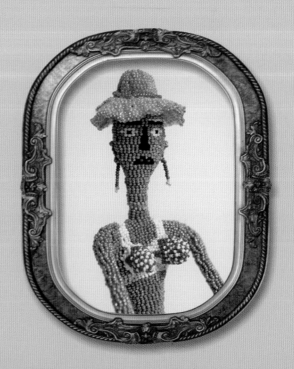

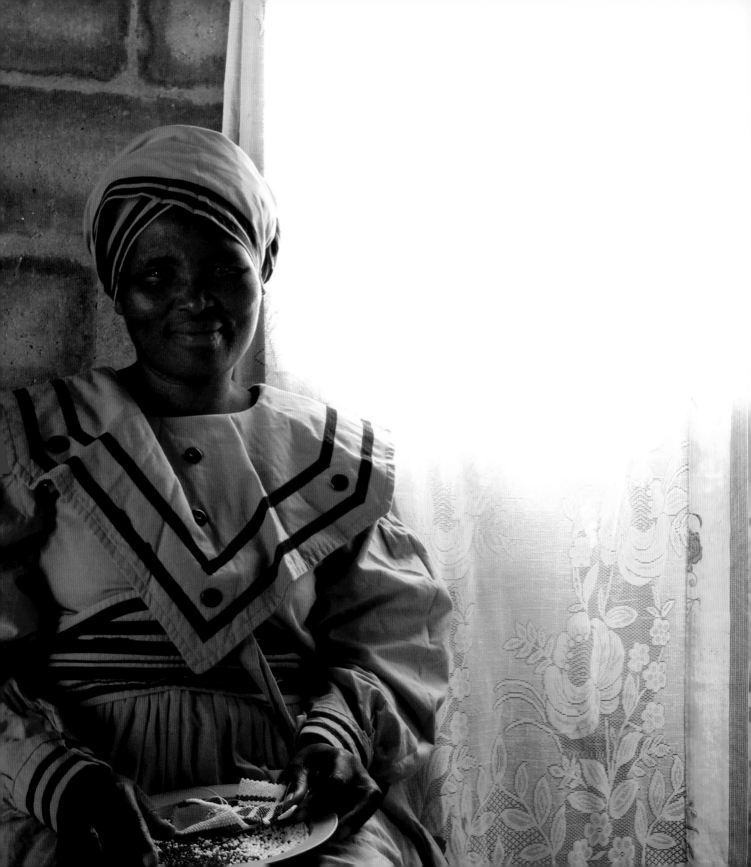

nokholekile
qhongwane, age 41

"Beading is in my blood," says Nokholekile, "even though I never learnt it from my mother or grandmother. But in the rural Transkei where I come from, beading is part of the culture."

Ironically, she had to leave her home for the city (in 1987) in order to re-establish the beading connection through joining Monkeybiz. She excels at making animals and dolls and recently **produced a stunning, gigantic beaded beer bottle for the South African Breweries head office in London.**

A mother of seven children, Nokholekile relies on a government grant and income generated by her husband to help raise the family. Two of her kids, Ntombifikile (20) and Nomthandazo (16), work with Monkeybiz.

"Monkeybiz has been very good for us. One of my sons, Masilakhe, burned to death in a shack fire in 1994 when he was 15. The project paid for his burial and my plane ticket to the Transkei."

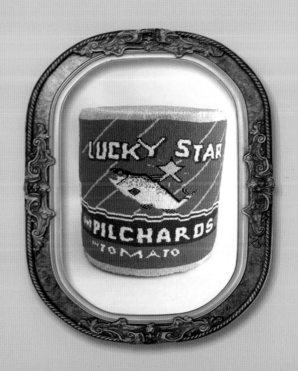

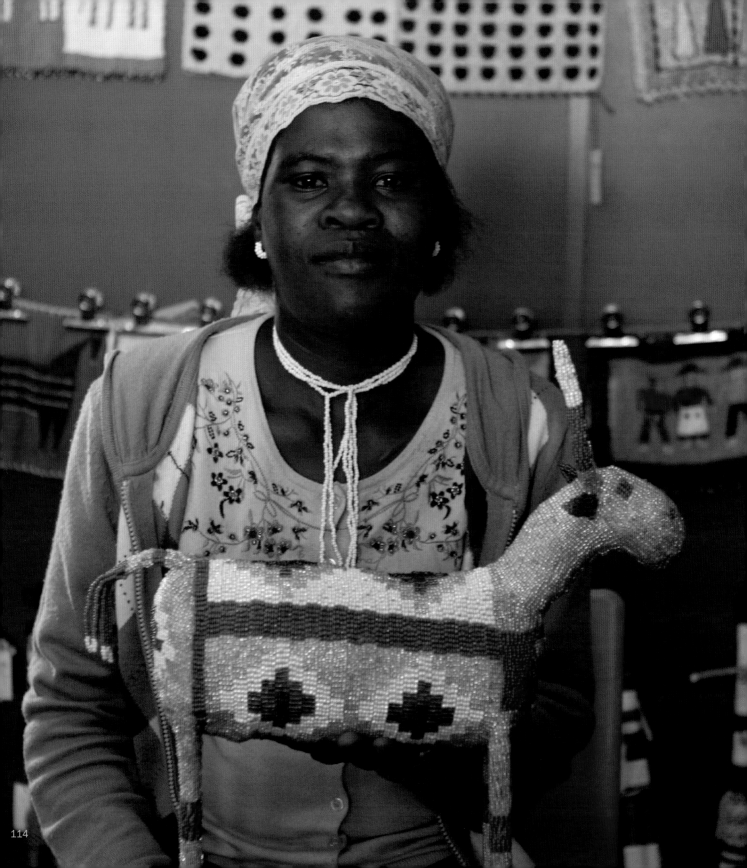

phathiswa
ncaphayi, age 33

An irrepressible character, Phathiswa is in training to become a sangoma, or traditional healer. In 2003, she was "called" in her dreams to *twasa* (train as a healer) by her ancestors.

She "took up the beads", wearing a symbolic beaded bracelet to signal to the community that her training had commenced. Throughout her initiation process, Phathiswa will bead a variety of bracelets, necklaces and headdresses to reflect her rites of passage.

The beading technique that Phathiswa uses to make her exquisite Monkeybiz dolls and her sangoma finery is essentially the same. "The only differences are the colour combinations and the materials I use," she says. "I only use cotton string when beading the Monkeybiz dolls, but when I bead a sangoma necklace I use the gut of a sacrificial goat that had been slaughtered as part of the initiation ceremony. The gut is from the intestine of the animal, which gets dried and rolled into a thin string. It is used as a sign of respect to the spirit of the animal."

Phathiswa feels that beading has brought purpose to her life. "It makes me feel great. I love doing the dolls as much as wearing a fine beaded necklace or headdress to a sangoma ceremony.

"When something is made with love, people really appreciate the beauty."

Phathiswa lives in Samora Machel, Philippi, with her two children, one of whom works with Monkeybiz. Her husband died in 2001.

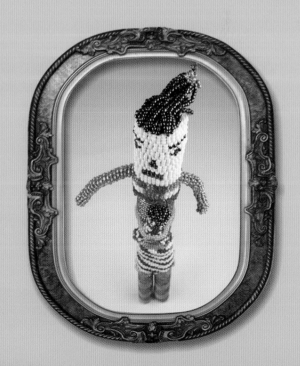

phumla
mramba, age 34

Having moved to Cape Town from the Transkei in 2001, Phumla knew how to do traditional beadwork. She had learnt it from her grandmother (in a village near Mount Frere in the Transkei) rather than her mother, who was a domestic worker in faraway Johannesburg and who consequently had precious little contact with her children.

Happily for Phumla, she quickly adapted to the contemporary style of Monkeybiz beading because her next-door neighbour in Macassar was none other than Makatiso Ngaka, the respected and much-loved "mama" of the project. "Makatiso is like a parent to me. I love her. Before she showed me the new style, I only knew 'straight' beading as found in traditional dresses and children's aprons."

Phumla has excelled in making small angels and large beaded replicas of Lion Matches, an iconic South African consumer product. She is also an expert at doing samples for a wide range of high-profile campaigns, most recently work commissioned by Amnesty International.

"I love to do them. I just look at the patterns for about two hours, studying all the details. Sometimes I copy a pattern from paper, then it's a matter of taking the process one bead at a time. I can bead anything – if you write down your name, I can do it in beads."

Both her children live in the Transkei and she sends them money every month through the income she generates with Monkeybiz. **"I feel very happy when I bead with the other women,"** she says. "I like being surrounded by them. We talk and listen to music. They also miss their children who are in the Transkei; we talk about what our children used to do in days gone by."

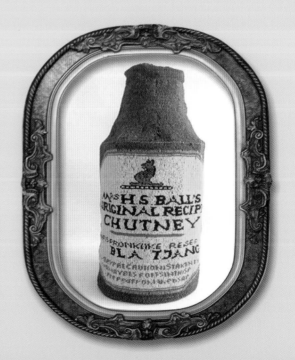

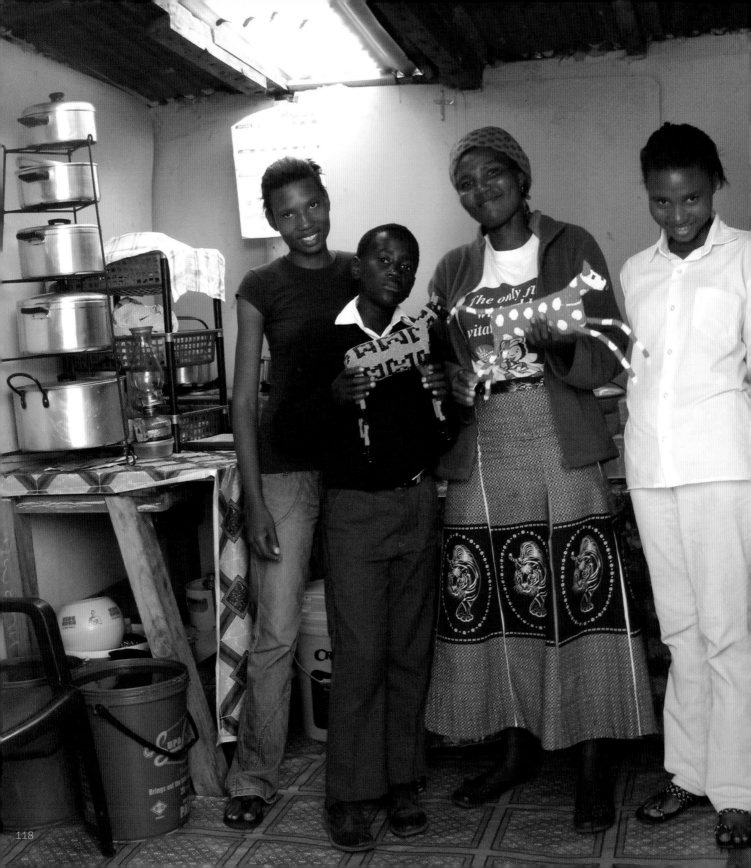

nosandise
mvinjana, age 35

Nosandise's love for gospel music reflects her religious devotion. She dreams of one day leaving the dwelling she shares with her husband Ezekile and three children (Nandipha, Mandisa and Sandise) and moving to a fancier house. She also hopes to do some travelling overseas to promote Monkeybiz.

"I thank God for all I have," she says. "I'm lucky that my husband, a construction worker, treats me well. Monkeybiz is also a blessing; I can now afford to pay school fees, buy groceries for the family and give financial support to my mother, who lives at our village in the Transkei.

"My beading experience has been amazing. I started with a necklace and have progressed to the point of making large animals with intricate patterns. **I feel proud of myself, especially when some of my work appears on television. It has inspired my entire family to take up beading."**

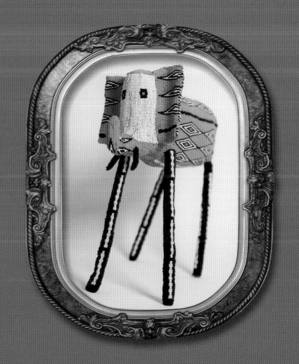

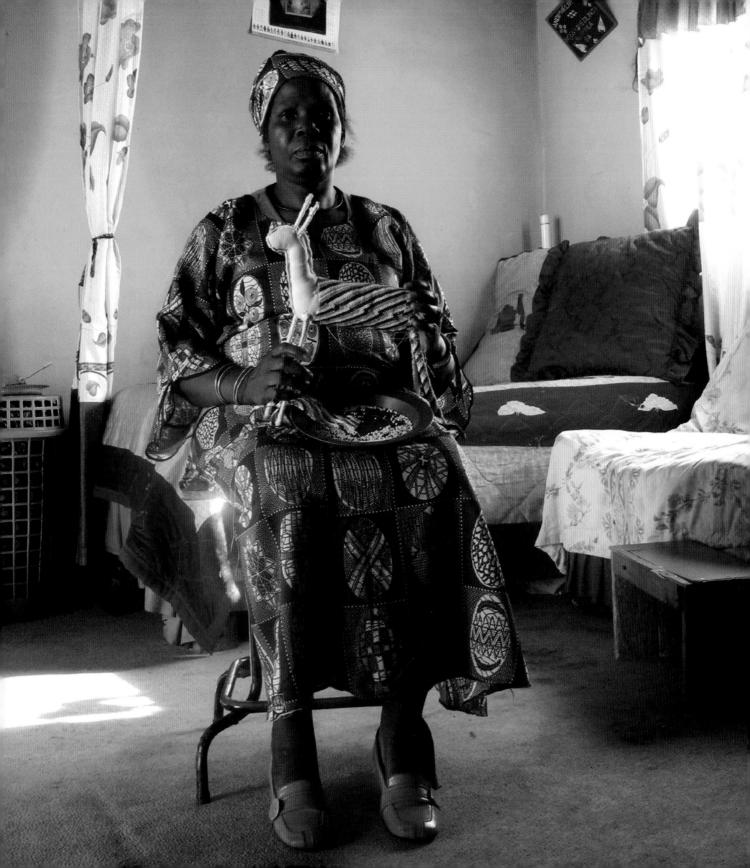

mamvundle
njemla, age 58

A colourful drawing of a lush potted plant adorns the front entrance to the cement-block house of Mamvundle and her husband Philemon Sajini Moshoeshoe in Kuyasa, Khayelitsha. It serves as a metaphor for her creative and financial growth since joining Monkeybiz in 2000.

Born and raised in Qumbu in the Transkei, Mamvundle learnt traditional Xhosa beading from her mother. Even so, she found switching to a more contemporary style quite challenging. "In the beginning I was very afraid I would make a mistake. But now I'm much more confident; I'm doing great!" The sophistication of her large beaded animals reflects her progress.

Growing up beading with her mother, she could never in her wildest dreams have imagined a project like Monkeybiz. **"Hayi! We used to wear traditional beaded bracelets in the Transkei, but no one thought you could turn this into a business.** When Monkeybiz found me and

Philemon, we were very poor. Now we're managing to save some money because most of our five children have left home. We still look after the youngest, Simthembile; at least we can afford to pay the school fees. Our neighbours in Kuyasa have all become interested in doing beadwork, so in our free time we're teaching many of them."

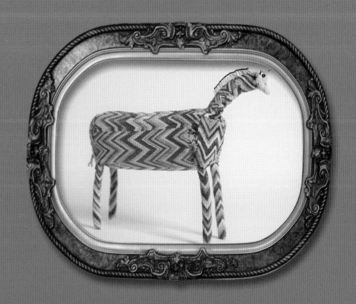

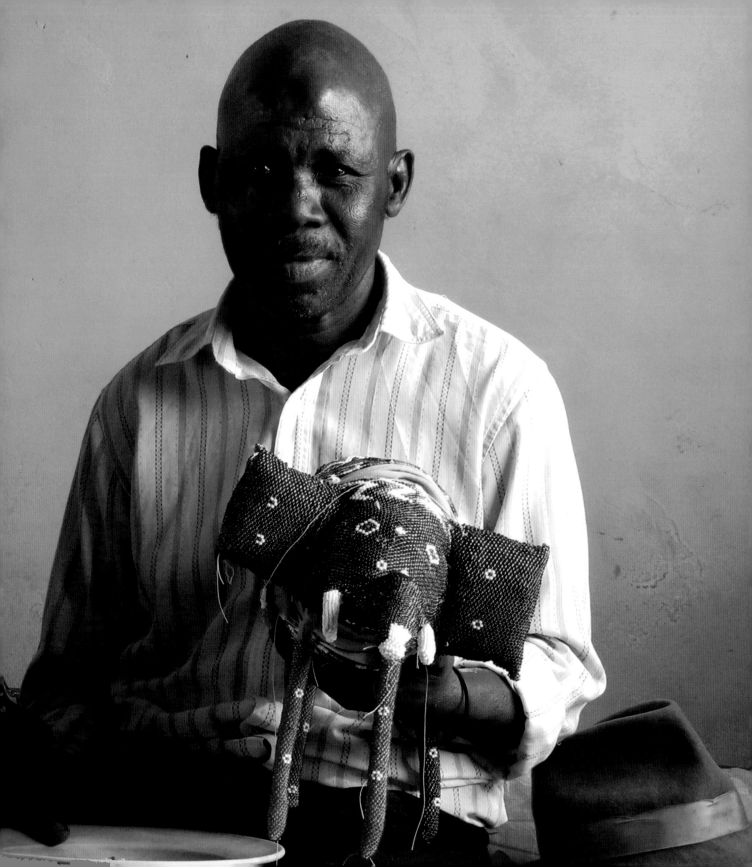

philemon sajini
moshoeshoe, age 60

Married to Mamvundle Njemla since 1969, Philemon and his wife form a formidable beading team. He turned to her for tuition in 2004 when his wood-logging career was abruptly ended by an accident. "I seriously damaged my right knee while splitting a log of wood," he grimaces. "If it weren't for Mamvundle and Monkeybiz, I would probably have been unemployed with **very little prospect of finding a new job.**"

Philemon has blossomed in his own right as the creator of exceptional beaded animals. When his photograph was taken he was busy putting the finishing touches to a large elephant bedecked with zigzags of white, dark brown and bottle green – a harmonious colour combination reflecting his male sensibilities.

In the more traditional setting of his birthplace (Qumbu is situated between Maclear and Mount Fletcher, close to the border between the Transkei and Lesotho), Philemon would probably not have been exposed to beading. Such activities are almost exclusively reserved for females. But he has taken the Monkeybiz challenge in his stride.

"In the beginning it was a bit difficult to pick up all the finer details of the work. But with every day that passes I feel I'm growing as an artist."

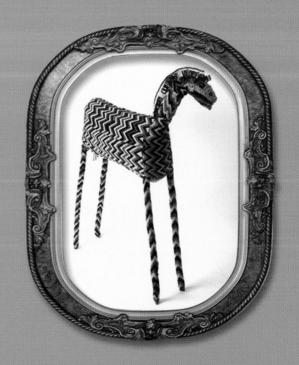

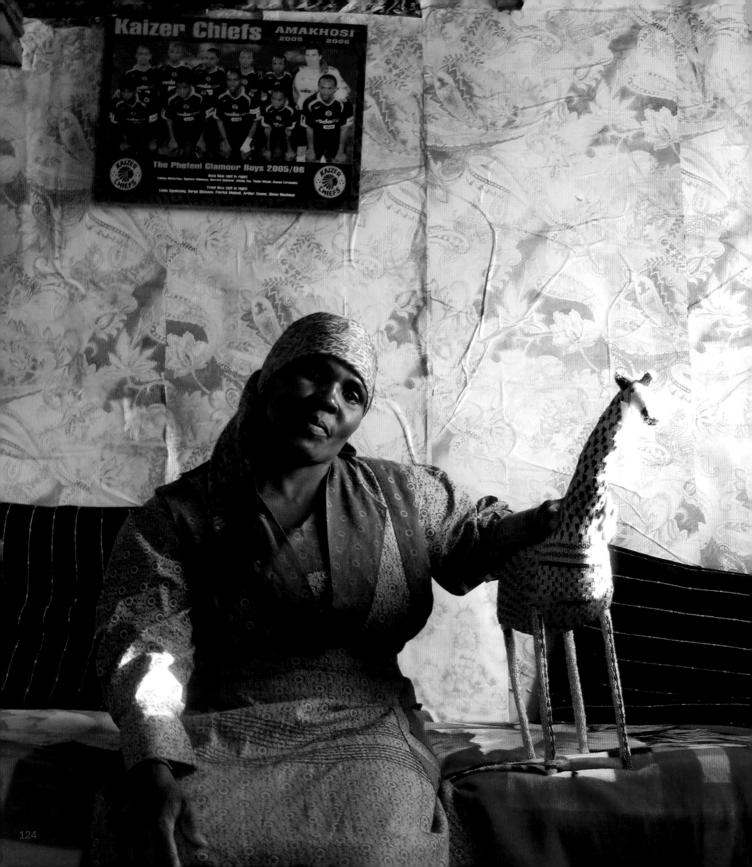

nomzoxolo jongqo, age 63

A framed photograph of her recently deceased husband Horatius and a poster of his favourite soccer team, Kaizer Chiefs, hang on one of the walls of a humble two-roomed dwelling in Enkanini, Khayelitsha, where Nomzoxolo does her beadwork.

Horatius, who had also done some beading with Monkeybiz, died suddenly of a heart attack, leaving Nomzoxolo to fend for five children. She finds the beading a solace during her process of mourning. "It has helped a lot, taking my mind off what has happened. **Beading helps me concentrate ... I guess you could call it a meditation of sorts.** I love it because I'm so much happier being creative at home than hanging out in the streets."

Born in a Transkeian village close to the Lesotho border near Mount Fletcher, Nomzoxolo moved to Cape Town in 2003. She joined Monkeybiz permanently in 2005 after learning beading from her sister-in-law, Nophuzile. Some of her favourite creations are large animals. "I like putting smart patterns on them and I feel proud to be part of a project that makes so many beautiful things."

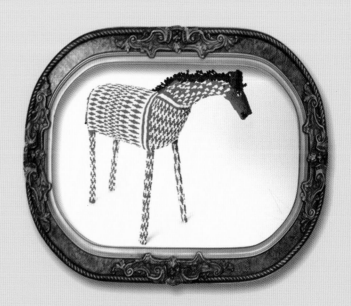

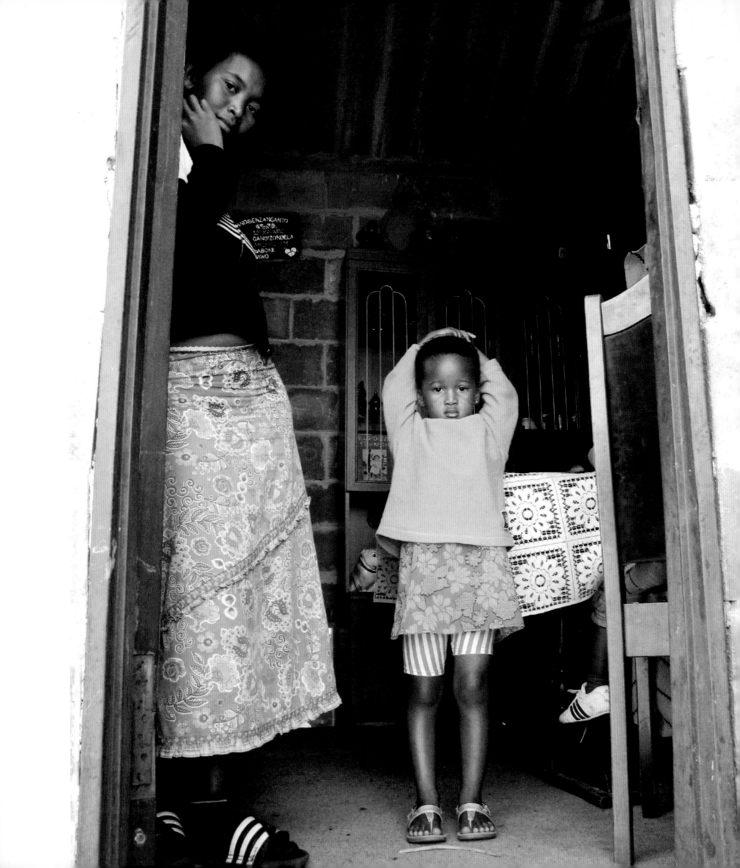

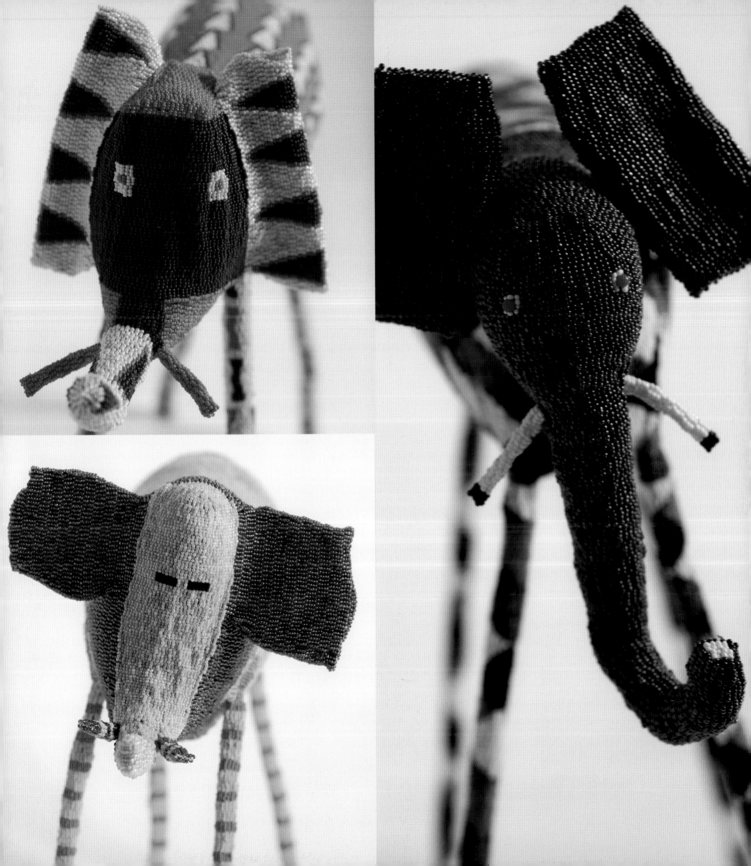

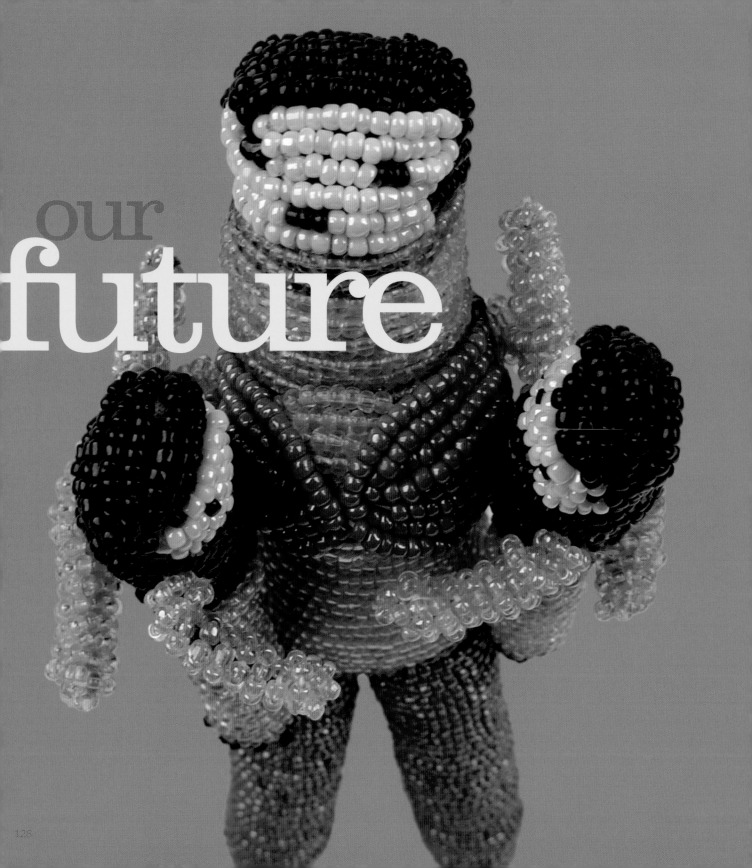

our
future

As a non-profit organisation orientated around its beading community, Monkeybiz focuses as much on meeting the needs of its artists as developing a captivating range of new artworks. Here are some of the objectives it plans to meet:

• Enhancing artistic careers

Monkeybiz is fast becoming known as having a fine stable of artists who have the potential to establish their credentials and earn a lot of money for themselves. It wants to continue promoting their work and document their progress.

• Caring for Aids orphans

Because so many Monkeybiz bead artists are HIV-positive, the grim reality is that some of them will develop Aids and die of the disease. This means the children they leave behind will need to be looked after. A fund to support Aids orphans is being formulated.

• Free eye tests and spectacles

Beadwork is a painstaking process that requires patience, skill – and good eyesight. Most Monkeybiz artists can't afford medical aid schemes and some are senior citizens. They need to see optometrists on a regular basis.

• Better lighting in homes

For many Monkeybiz artists in the townships, electricity is a luxury. Some work by candlelight or use paraffin lamps to light their homes. Even those with electricity often have inadequate lighting where they bead. Monkeybiz plans to rectify this shortcoming.

• Access to nutritious food

Because of conditions of extreme poverty in the townships, few people eat fresh vegetables on a daily basis. Monkeybiz wants to lead the way by helping artists establish organic vegetable gardens for basic nutrition.

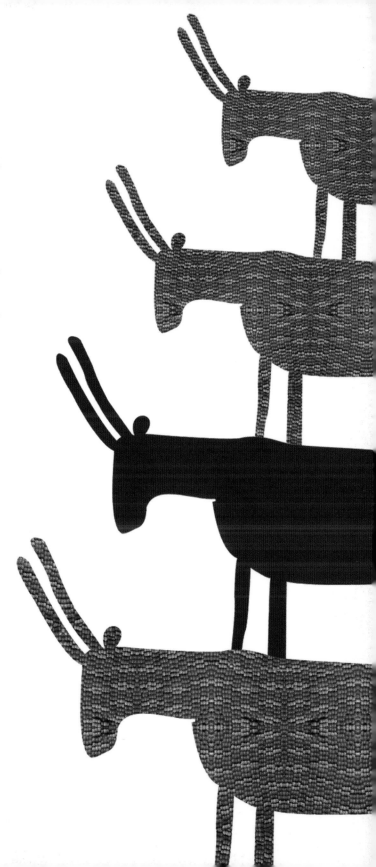

• Creating more crèche facilities

Although Monkeybiz supports a crèche at its Wellness Clinic once a week, it would like to establish a permanent service to mothers in the townships, thus freeing them up from household chores. This means it would have to create and staff three separate nurseries in Macassar (Khayelitsha), Samora Machel (Philippi) and Imizamo Yethu (Mandela Park, Hout Bay).

• Building a community centre

The California-based Art Aids Art (founded by Tom Harding and Dorothy Yumi Garcia), in conjunction with benefactors from Harvard University's graduate school of design and architecture, is building a community centre in Macassar, Khayelitsha – a neighbourhood filled with Monkeybiz bead artists – that will double as a Bed & Breakfast establishment. Known as *Ekhaya Ekasi* (which means Home in the 'Hood), it will upon completion serve as a hub supporting small businesses such as a hairdresser's salon, a photographic shop, a tourist centre, and an arts and entertainment centre.

• Ongoing skills training programme

With the continual growth of Monkeybiz, many people aspire to become bead artists. To become skilful and develop a special talent, however, requires many hours of training, which puts a premium on teaching and managing the process. More teachers need to be trained and more funding is essential to underpin the initiative.

• Greening of townships

Monkeybiz always searches for ways to improve the quality of life of its artists. It wants to help build the townships from within. The planting and maintenance of trees would help improve the environment.

• Spreading the spirit of *ubuntu*

Finally, Monkeybiz wants to deepen its commitment to the philosophy of *ubuntu*. Says Barbara: "We like going to sleep at night feeling OK that other people are OK."

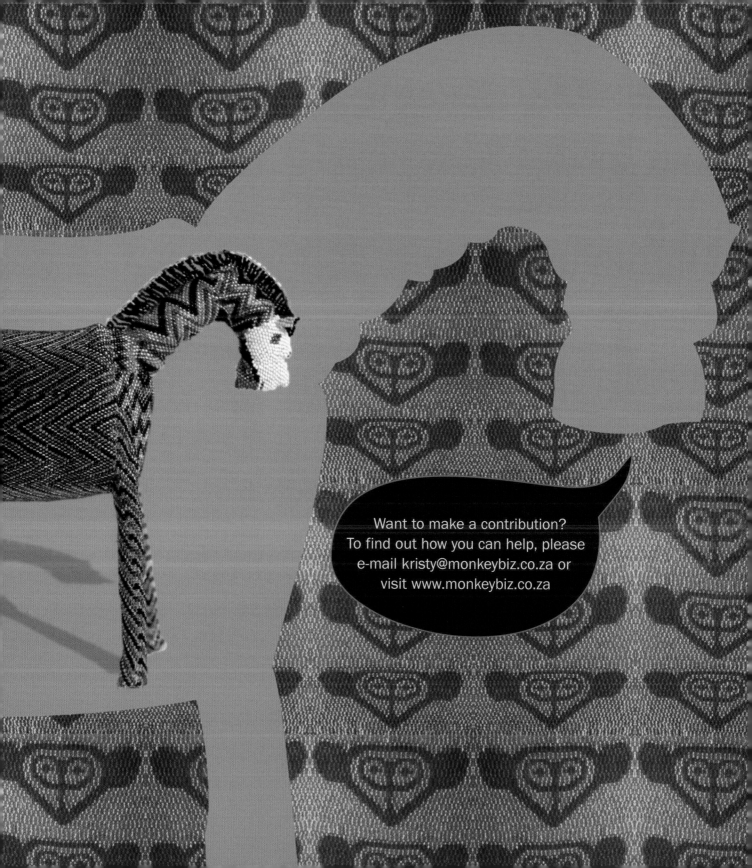

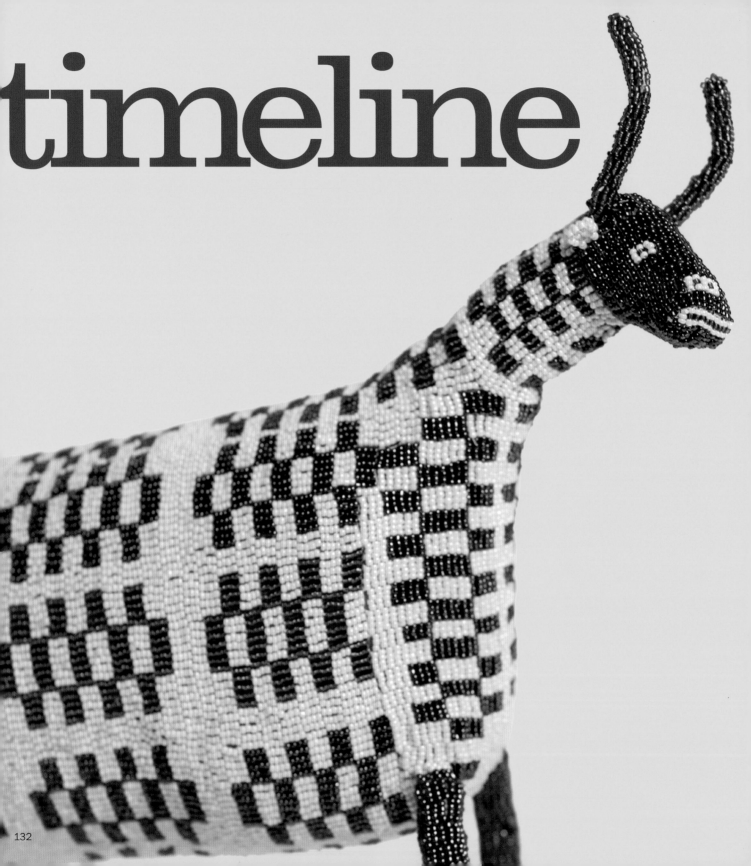

timeline

2000

- Monkeybiz founded; basic training commences; only dolls are produced; initial media coverage; people think we are mad; we do have sleepless nights!

2001

- Animals and beaded pictures introduced; the struggle continues.

2002

- Monkeybiz begins to export to Japan, Australia, the United States and Europe.
- Short promotional film on Monkeybiz made by Isandi, Norway.
- Monkeybiz features in a major exhibition at Manor House, Spier Wine Estate, Stellenbosch, South Africa.
- Aids clinic launched in a humble room.

2003

- Beadwork commissioned as gifts to scholars attending the Mandela Rhodes Trust Centenary.
- Monkeybiz features in *Leadership* magazine.
- Cape Town International Convention Centre commissions Monkeybiz to bead 450 lightshades for its new premises.
- Monkeybiz features in the November issue of *House and Leisure*.
- Launch of Monkeybiz book, *Positively HIV* with a five-track music CD called *Statements*. It aims to educate the youth about HIV/Aids.
- California-based Art Aids Art and a group of African American women sell Monkeybiz artworks to raise funds for the purchase and installation of a shipping container called The Boat in Khayelitsha. It serves as a production centre for the Recycled Rubber Project.

2004

- Two Monkeybiz artists attend the Santa Fe International Folk Art Market, United States.
- Cape Craft and Design Institute names Monkeybiz as a South African icon.
- Museum of Arts and Design in New York purchases two Monkeybiz artworks for its permanent collection.
- Two artworks known as *The Boxers* are placed in the private office of Mr Nelson Mandela, the former South African president.
- Artworks are purchased for the permanent collection of the Mandela Foundation in Houghton, Johannesburg.
- American designer Donna Karan visits Monkeybiz and purchases Monkeybiz artworks.
- Monkeybiz artworks appear in *Dazed and Confused* magazine.
- Anglo American plc (United Kingdom) sponsors a Monkeybiz exhibition at the Flow Gallery, Notting Hill, London, and at its head office in St James.
- Cult actor Rutger Hauer and his wife Inneke visit Monkeybiz.
- Carrol Boyes Functional Art Store in New York purchases Monkeybiz artworks.

2005

- Monkeybiz participates in the annual Design Indaba at the Cape Town International Convention Centre.
- Li Edelkoort, an international trend forecaster, learns about Monkeybiz at the Indaba and invites it to participate in an exhibition in Paris called 'North Meets South'.
- Beadwork purchased by Giraffe restaurant chain in London.
- The Monkeybiz story is used in the case-study pack by the Woolworths Design Programme; it is distributed to schools and design institutions.

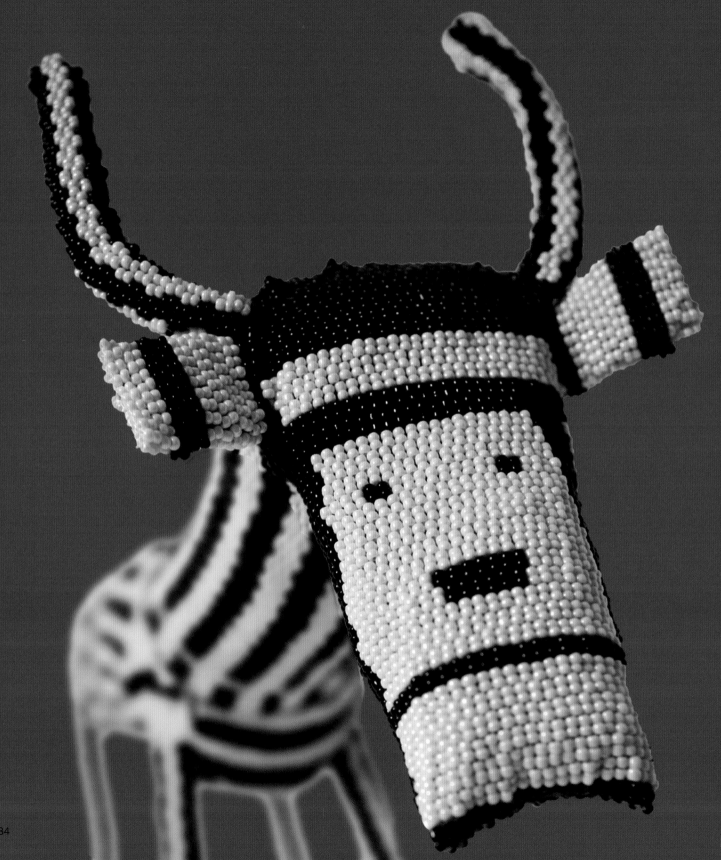

2005 (continued)

- On-going purchase of Monkeybiz artworks by the Mingei International Museum, San Diego.
- On-going purchase of Monkeybiz artworks by Peace Please, New York. This organisation strives to promote peace throughout the world.
- The National Gallery, London, purchases Monkeybiz artworks for its gallery store.
- Barbara Jackson and Shirley Fintz, two of the three founding directors, travel to London to accept UK Coalition of People Living with HIV/Aids DoUKCare Hero Award on behalf of Monkeybiz – one of four international projects to receive this award.
- Monkeybiz community leader Eunice Yoliswa Mlotywa and Barbara Jackson attend the 46664 concert in Tromsø, Norway.
- Dr Mamphela Ramphele becomes the patron of Monkeybiz. The first woman and the first black South African to be named vice-chancellor of the University of Cape Town, she also served as one of four directors of the World Bank. She is currently executive chairperson of Circle Capital Ventures.
- Monkeybiz receives ongoing commissions of artworks for many countries in the world through IFAW, the International Fund for Animal Welfare.
- Monkeybiz participates in the Santa Fe International Folk Art Market.
- ABC Carpet & Home Store in New York holds a Monkeybiz exhibition.
- Monkeybiz takes Australia by storm.
- Carrol Boyes Functional Art Store in Greece purchases Monkeybiz artworks.
- Carrol Boyes Functional Art Store in Paris purchases Monkeybiz artworks.

2006

- Monkeybiz participates in the Design Indaba at the Cape Town International Convention Centre.
- Monkeybiz participates in the Santa Fe International Folk Art Market.
- Monkeybiz creates artwork for the Jewish Federation of Greater Atlanta; the pieces are displayed as part of the Tsdakkah exhibition at the Bremen Museum.
- Monkeybiz features in a television programme called *Head Wrap* on SABC1.
- New York première of documentary film on Monkeybiz called *Bigger than Barbie*.
- Monkeybiz artworks used as décor for the Oprah Winfrey Leadership Academy for Girls, which was launched at Henley-on-Klip, Meyerton, Johannesburg.
- Opening of the Monkeybiz retail store in the Bo-Kaap, a historic Cape Town neighbourhood, in July 2006.
- Monkeybiz completes a commission of gigantic beaded beer bottles for South African Breweries plc, London.
- Barbara Jackson attends a conference of the Alliance for a New Humanity, in Puerto Rica.
- Open Arms, an Aids organisation in Minneapolis, sponsors a Monkeybiz exhibition and screening of the documentary film *Bigger than Barbie*, on World Aids Day.
- Monkeybiz artworks feature at World Aids Day in Chicago.
- *Bigger than Barbie* premièred in Cape Town at the new Monkeybiz store.
- *Bigger than Barbie* shown at the Screenwriters Guild, Los Angeles.

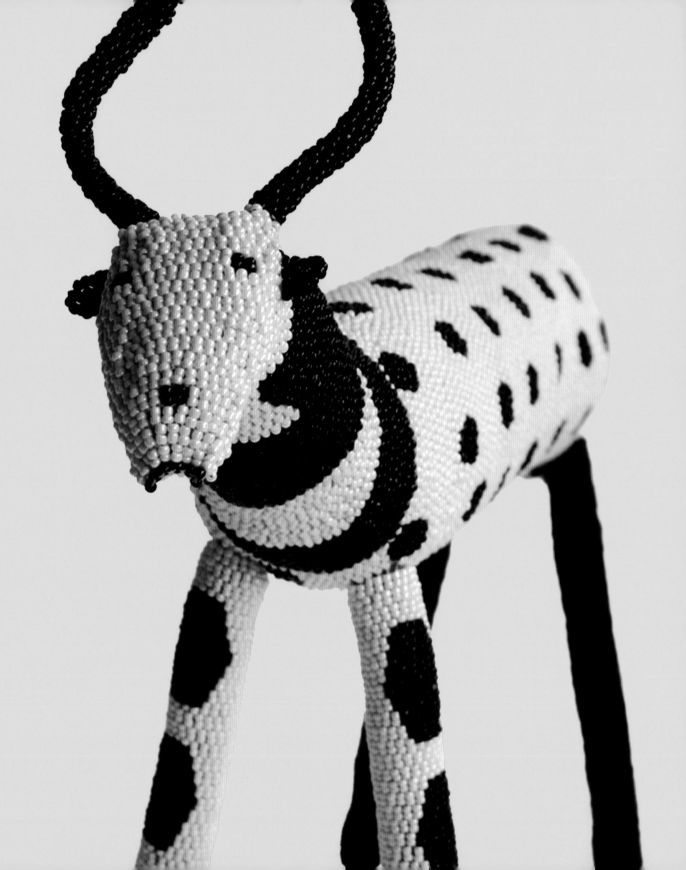

2007

- Barbara Jackson sits on two discussion panels at the Vital Voices African Women's Leadership Summit, Cape Town.
- Monkeybiz beadwork used to decorate the costumes and ballet shoes of the Cape Town City Ballet production *Nomvula*.
- Monkeybiz gets a commission to make beaded basketball players for Hoops for Hope, an initiative of the National Basketball Association, United States.
- Linda Warren Gallery in Chicago features a Monkeybiz exhibition.
- Jewish Museum in New York commissions Monkeybiz artworks for its permanent collection.
- Carrol Boyes Functional Art Store in Paris purchases Monkeybiz pieces.
- Carrol Boyes Functional Art Store in Greece purchases Monkeybiz pieces.
- Carrol Boyes Functional Art Store in Sandton City, Johannesburg, buys Monkeybiz pieces.
- Participates in the Design Indaba at the Cape Town International Convention Centre.
- Barbara Jackson meets with the students of the Graduate School of Design and Architecture, Harvard Business School. She screens the documentary film *Bigger than Barbie* and gives a talk regarding the new Community Centre in Macassar, Cape Town.
- Amnesty International commissions Monkeybiz to design beadwork for its campaign, Stop Violence Against Women.
- Monkeybiz participates in the Santa Fe International Folk Art Market.
- *Bigger than Barbie* features at the Paris International Women's Film Festival.

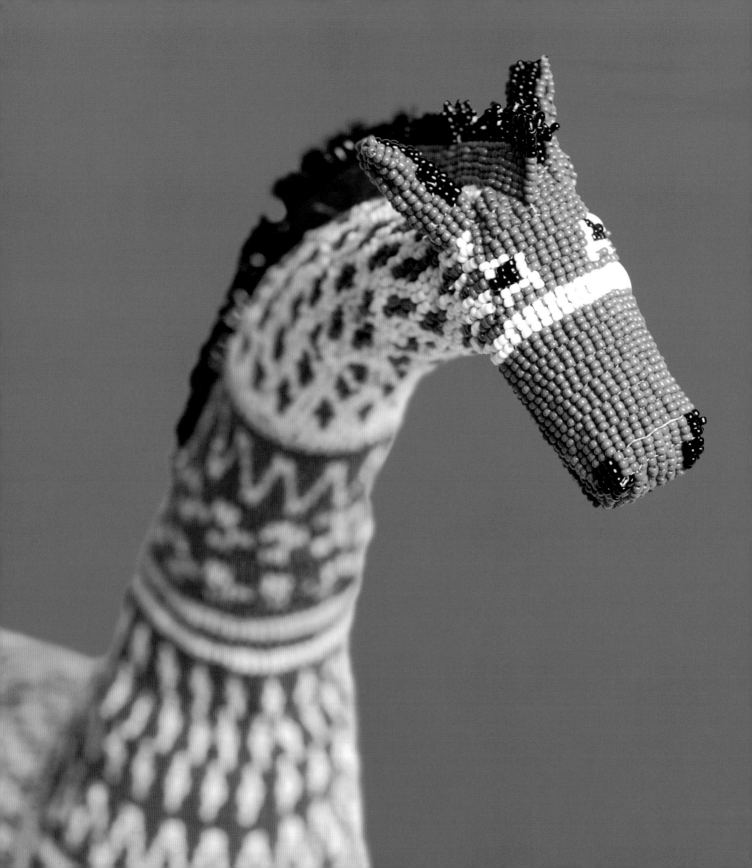

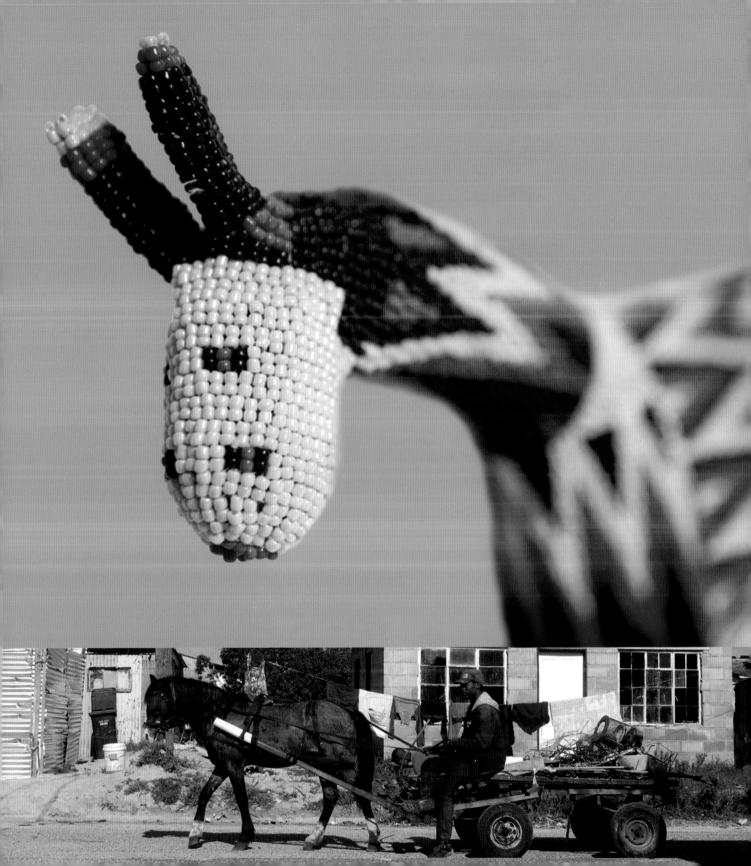

Photography:
Brett Rubin,
David Chancellor

2 + 3

Photography:
David Chancellor,
Dion Viljoen

4 + 5

Photography:
Brett Rubin,
David Chancellor,
Martine Jackson,
Dion Viljoen

6 + 7

Photography:
Brett Rubin,
Circle Capital Ventures

8 + 9

Photography:
Brett Rubin,
Oryx Media,
Timothy White

10 + 11

Photography:
Brett Rubin,
Rutger Hauer

12 + 13

Photography:
David Chancellor

14 + 15

Photography:
Dion Viljoen

16 + 17

Photography:
Dion Viljoen

18 + 19

Photography:
Dion Viljoen

20 + 21

Photography:
Dion Viljoen

22 + 23

Photography:
Brett Rubin

24 + 25

Photography:
Brett Rubin,
Dion Viljoen

26 + 27

Photography:
Brett Rubin

28 + 29

Photography:
Joachim Hoge

30 + 31

Photography:
Brett Rubin,
Dion Viljoen

32 + 33

Photography:
David Chancellor,
Brett Rubin,
Martine Jackson

34 + 35

Photography:
Brett Rubin,
David Chancellor

36 + 37

Photography:
Brett Rubin,
Dion Viljoen

38 + 39

Photography:
Brett Rubin,
David Chancellor

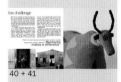

40 + 41

Photography:
Martine Jackson,
Brett Rubin

42 + 43

Photography:
David Chancellor

44 + 45

Photography:
David Chancellor,
Martine Jackson
Artist: Thembikosi Mafrika
h: 56cm x w: 50cm

46 + 47

Photography: Brett Rubin,
David Chancellor
Artist: Jeremiah Moloi
h: 38cm x w: 12cm

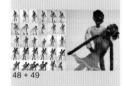

48 + 49

Photography: Dion Viljoen
Artist: Asanda Sotomela
h: 30cm x w: 21cm

50 + 51

Photography: David Chancellor
Artist: Vangile Manqamane
h: 40cm x w: 60cm
Artist: Nosibulele Nombewu
h: 50cm x w: 50cm

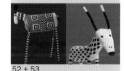

52 + 53

Photography: David Chancellor
Artist: November Zwane
h: 38cm x w: 12cm

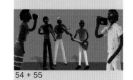

54 + 55

Photography:
Brett Rubin,
David Chancellor
Artist: Phumla Mramba
h: 25cm x w: 15cm

56 + 57

Photography:
David Chancellor
Artist: Sibongile Moloi
h: 38cm x w: 12cm

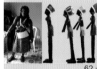

58 + 59

Photography:
David Chancellor
Artist: Nomakhaya Qoqa
h: 30cm x w: 27cm

60 + 61

Photography:
Martine Jackson,
David Chancellor
Artist: Nthabiseng Maseu
h: 38cm x w: 12cm

62 + 63

Photography:
Martine Jackson,
David Chancellor
Artist: Jeremiah Moloi
h: 38cm x w: 12cm

64 + 65

Photography:
David Chancellor
Artist: Mahadi Mashilone
h: 38cm x w: 12cm

66 + 67

Photography:
David Chancellor
Artist: Regina Ngozi
h: 40cm x w: 50cm

68 + 69

Photography:
Brett Rubin,
David Chancellor
Artist: Nobantu Mtshalala
h: 32cm x w: 27cm

70 + 71

Photography:
David Chancellor
Artist: Nandipha Mvinjana
h: 42cm x w: 29cm

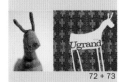

72 + 73

Photography: Dion Viljoen, David Chancellor
Artist: Khethiwe Ndlovu, h: 46cm x w: 30cm
Artist: Thulani Jongqo, h: 70cm x w: 60cm

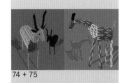

74 + 75

Photography: Brett Rubin,
David Chancellor
Artist: Grace Ntsingila
h: 38cm x w: 12cm

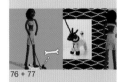

76 + 77

Photography: David Chancellor
Artist: Nozolile Madotyeni
h: 45cm x w: 52cm
Artist: Vangile Manqamane
h: 43cm x w: 30cm

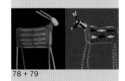

78 + 79

Photography:
Brett Viljoen, Dion Viljoen
Artist: Noweekend Chizelana
h: 30cm x w: 22cm

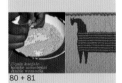

80 + 81

Photography: David Chancellor
Artist: Nthabiseng Tshotetsi
h: 38cm x w: 12cm
Map: Copyright © Map Studio 2007
www.mapstudio.co.za

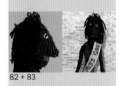

82 + 83

Photography:
David Chancellor
Artist: Ntombizanele Libalele
h: 27cm x w: 30cm

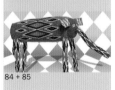

84 + 85

Photography: David Chancellor
Artist: Patricia Dlabane
h: 45cm x w: 8cm
Artist: Nophelo Magayiyana
h: 46cm x w: 7cm

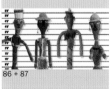

86 + 87

Photography:
David Chancellor
Artist: Nosakhele Nhanha
h: 52cm x w: 40cm

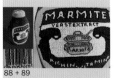

88 + 89

Photography:
Dion Viljoen, Brett Rubin
Artist: Edith Matunduka
h: 30cm x w: 22cm

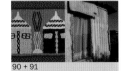

90 + 91

Photography: David Chancellor
Artist: Nosakhele Nhanha
h: 49cm x w: 22cm
Artist: Noloyiso Mphakathi
h: 60cm x w: 36cm

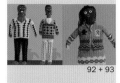

92 + 93

Photography:
Brett Rubin

94 + 95

Photography:
Brett Rubin

96 + 97

Photography:
Brett Rubin,
David Chancellor

98 + 99

Photography:
Brett Rubin,
David Chancellor

100 + 101

Photography:
Brett Rubin,
Dion Viljoen

102 + 103

Photography:
Brett Rubin,
David Chancellor

104 + 105

Photography:
Brett Rubin,
David Chancellor

106 + 107

Photography:
Brett Rubin,
David Chancellor

108 + 109

Photography:
Brett Rubin,
David Chancellor

110 + 111

Photography:
Brett Rubin,
David Chancellor

112 + 113

Photography:
Brett Rubin,
Dion Viljoen

114 + 115

Photography:
Brett Rubin,
David Chancellor

116 + 117

Photography:
Brett Rubin,
David Chancellor

118 + 119

Photography:
Brett Rubin,
David Chancellor

120 + 121

Photography:
Brett Rubin,
David Chancellor

122 + 123

Photography:
Brett Rubin,
David Chancellor

124 + 125

Photography:
Brett Rubin,
David Chancellor

126 + 127

Photography:
Dion Viljoen

128 +129

Photography:
David Chancellor

130 + 131

Photography:
David Chancellor

132 + 133

Photography:
David Chancellor

134 + 135

Photography:
Zia Bird,
Dion Viljoen

136 + 137

Photography:
David Chancellor,
Brett Rubin

138 + 139

To purchase the artworks displayed in this book or to view the extensive range of Monkeybiz pieces, visit the Monkeybiz online store:

www.monkeybiz.co.za

MONKEYBIZ
SOUTH AFRICA